kittens in the sun

kittens in the sun

Hans Silvester

CHRONICLE BOOKS

SAN FRANCISCO

Printed in France

ISBN 0-8118-2571-X

Library of Congress
Cataloging-in-Publication Data available.

Jacket design: David Valentine

Distributed in Canada by
Raincoast Books
8680 Cambie Street
Vancouver, B.C. V6P 6M9

10 9 8 7 6 5 4 3 2 1

Chronicle Books
85 Second Street
San Francisco, California 94105

www.chroniclebooks.com

a kitten's life begins in darkness. Blind at birth, its first impression is of a black, narrow world in which the imperatives are to eat, to sleep, and to stay close to the warmth that is its mother. The purring of kittens beside their mother is the sound of true happiness.

During the first weeks, the mother is very tender and affectionate: she almost never leaves her kittens, doing everything possible to help them. Her milk contains all the nourishment they need, and on a regular regime of food and rest, they develop rapidly. The mother uses her tongue to keep them clean, ensuring that no mess long remains in their hiding place.

If their security is threatened, she moves them, taking each by the scruff of the neck and carrying them to a safer location. The father never approaches the kittens; at his first attempt, the mother fiercely chases him away. The mother's loyalty to her youngsters is total. In the face of danger, she is fearless. On numerous occasions, I have seen

furious female cats chase off dogs. I remember vividly one mother that leapt on a curious dog's back, digging her claws into its fur and biting its neck. The horrified dog fled, with the cat clinging to its back!

After about two weeks, their eyes begin to see. At first, these little bundles of fur are primarily blue-eyed, although gradually the colors

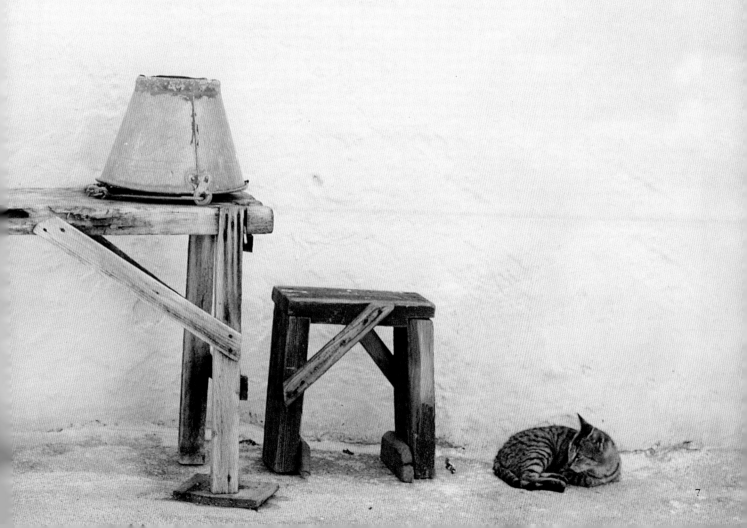

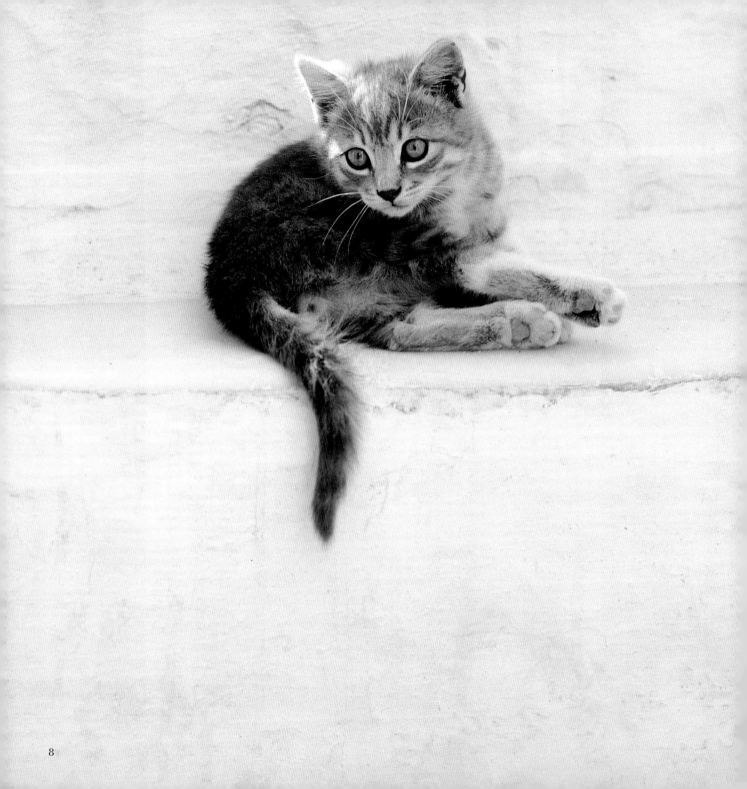

change. Even as they begin to explore the world around them, the kittens are growing rapidly into little cats. Clumsy at first, they begin to investigate their surroundings. Curious and playful, bursting with energy, they encourage one another to venture further and further from their home.

Developing quickly, they are soon mischievous, self-assured little devils. As they play with their brothers and sisters, the kittens learn about their world. Even at the age of three weeks, they possess that uncanny ability to always land on their feet. Beautiful and elegant, lively and smart, the kittens boldly strive to master their world.

Far from defenseless, they have sharp claws and tough little teeth to threaten any attacker. Try to catch and hold a kitten, and your

hand will be bloodied. Even domestic kittens possess that wild streak. Patience and love may eventually overcome the kittens' natural suspicion and fear, but you must devote long hours to developing a friendly relationship. Cats are willing to share their lives with humans, on the condition that we grant them a certain liberty and independence.

Even as the kittens grow bolder and range more widely from home, their mother, who had been so attentive, grows distant. She is tired,

forced to provide more and more milk and finding less time to rest. Formerly strong, she is now in need of food herself. She teaches them to hunt by letting them play with her tail, until one day, for the first time, she brings the kittens prey. It may be a small bird or a mouse. Suddenly, the games are over. Hissing fiercely, the young cats attack the victim and devour it.

With the abundance of cats in the Greek Islands, prey can be hard to find, so the mother frequently brings fish instead. It is a common sight to see cats returning from the port, carrying a still struggling fish in their mouths. The local fishermen love the cats and are generous with their catch. Local women also put out food for the cats.

At two months, the young cats are incredibly quick and agile, taking great pleasure in clowning around. Everything seems an excuse for play: a blowing leaf, a crawling insect, a weaving butterfly. The brothers and sisters squabble playfully, stopping only when they drop down exhausted, to sleep deeply, then waking, full of energy.

On the Cyclades Islands, the villages have narrow, winding passageways where the kittens often play. They particularly like the areas near

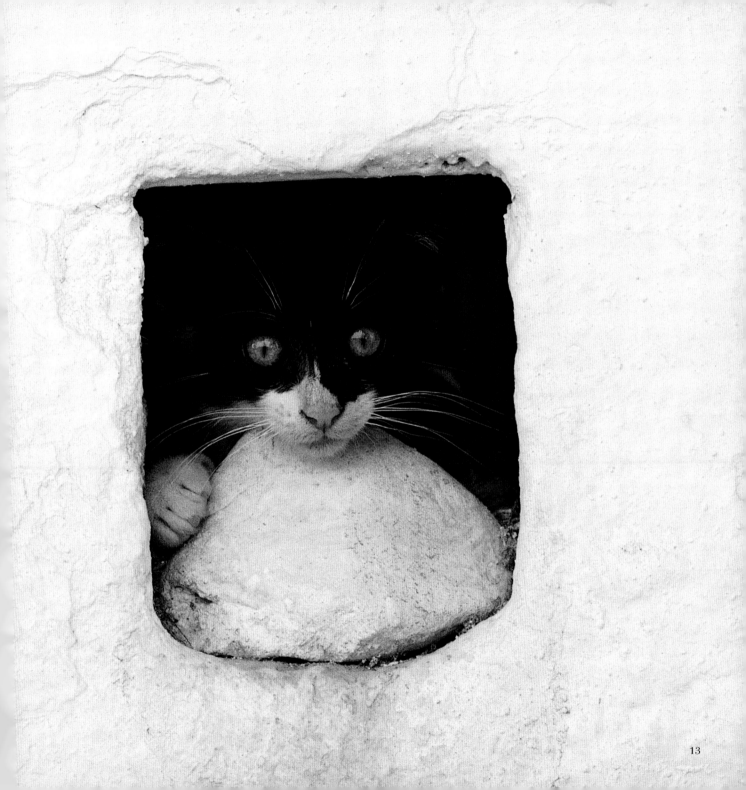

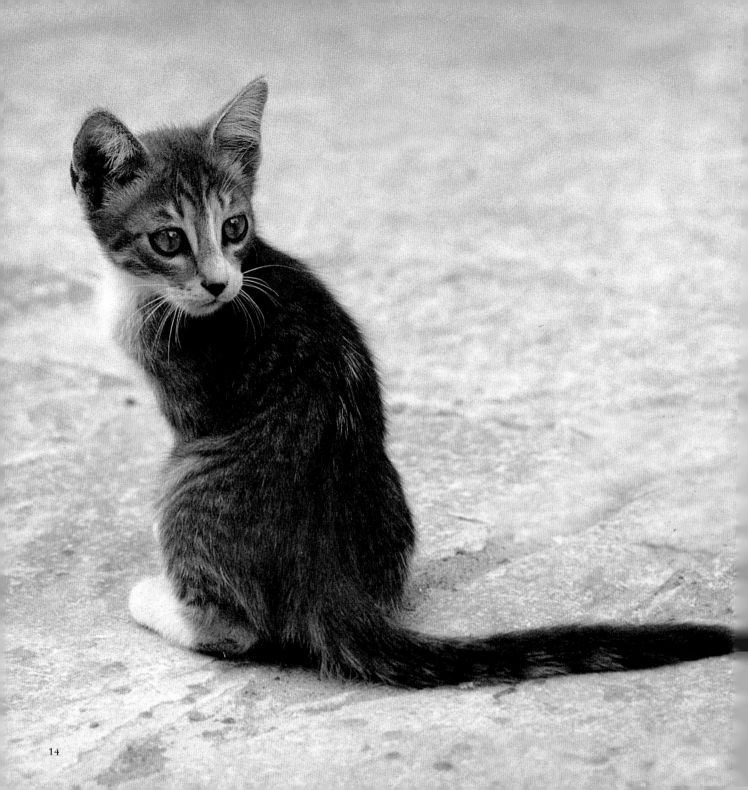

the fishing port. Sometimes the young of many litters come together to form a band. Watchful and concerned, the mothers observe but leave the kittens to their play. The locals and tourists take great pleasure in watching the activity. The kittens' joie de vivre is obvious. Through their play, the kittens learn to be wild cats.

As the separation from their mother continues, the kittens start to rebel. For her part, the mother, formerly full of tenderness, disappears for hours at a time, leaving the kittens on their own. Now the kittens expand their territory and become acquainted with other cats. Always hungry, they must learn to hunt, to find their food, to survive on their own.

The females are more precocious than the males. At the age of one year, many are often pregnant. On the other hand, the males take perhaps two years to reach complete development. Even then, life for the adult cats is not easy on the islands. Danger can come from anywhere, from attacking dogs, uncaring humans, disease, and hunger. People not familiar with the cats of the Greek Islands might attempt to protect them. But the Greek inhabitants believe that the wild cats are not pets, so they should be allowed to live and to thrive on their own, in the wild, as they have for centuries.

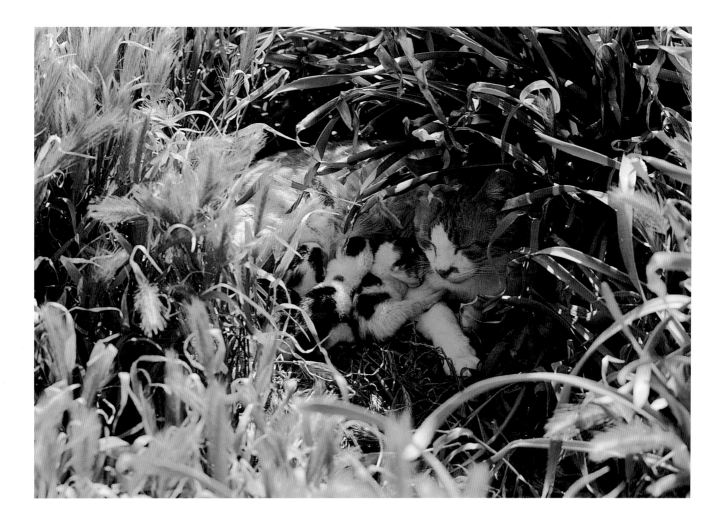

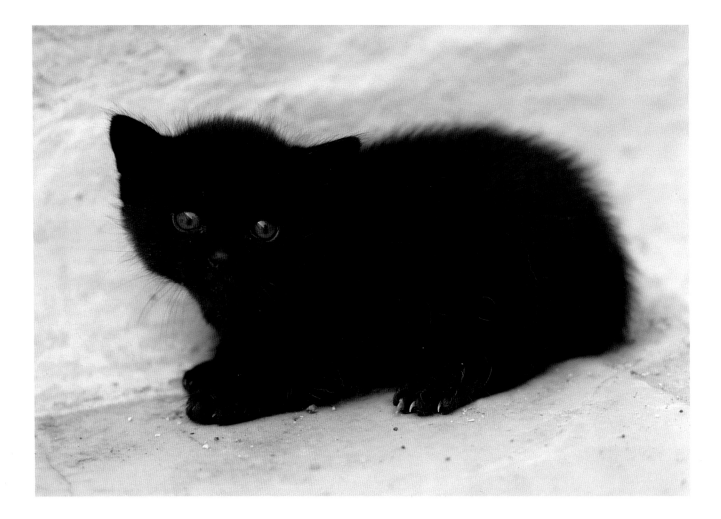

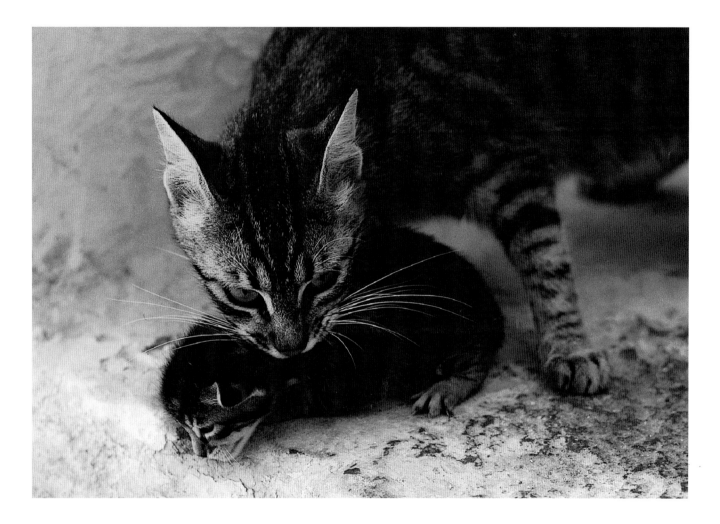

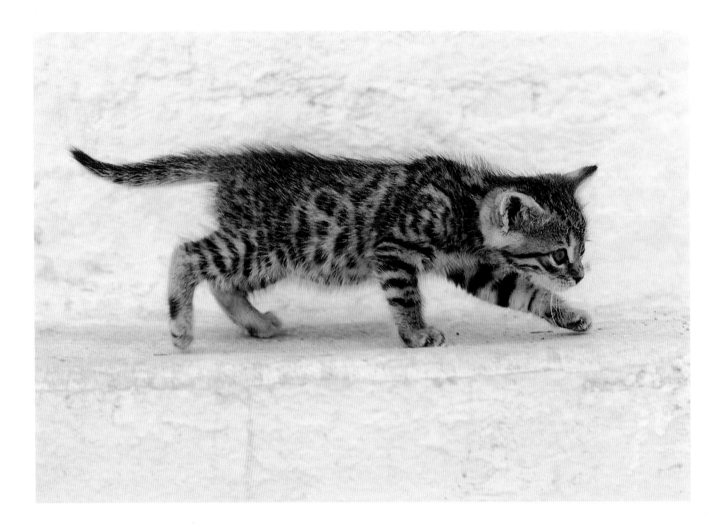

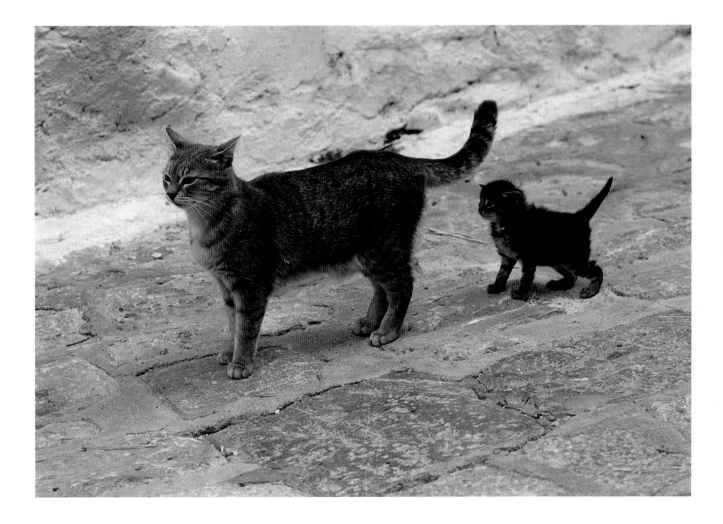

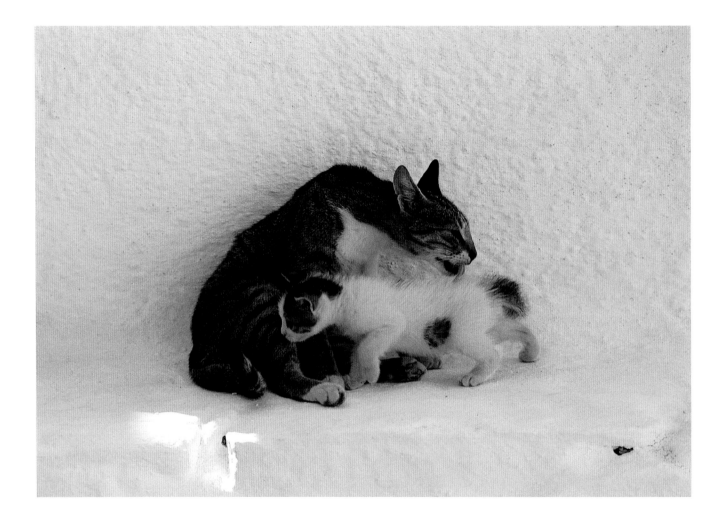

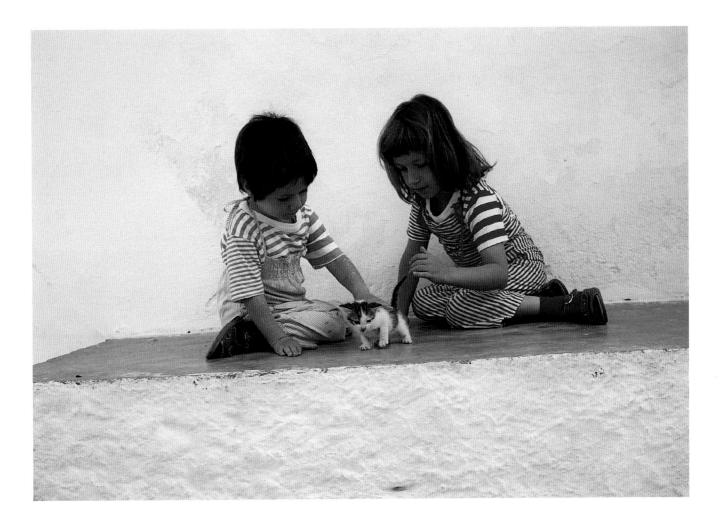

23

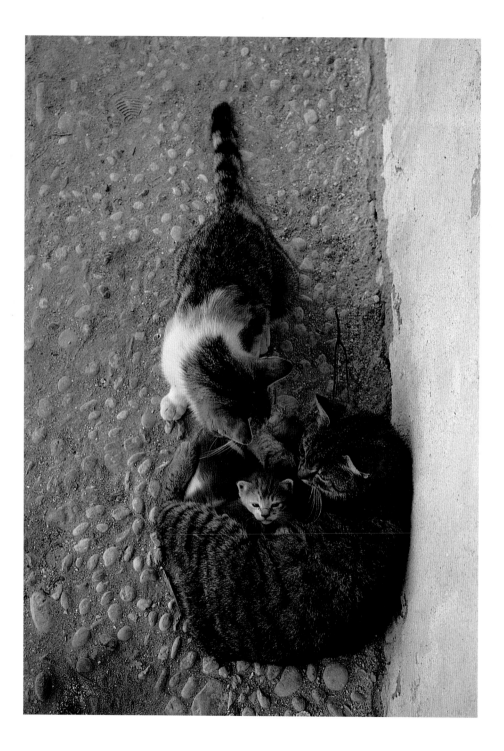

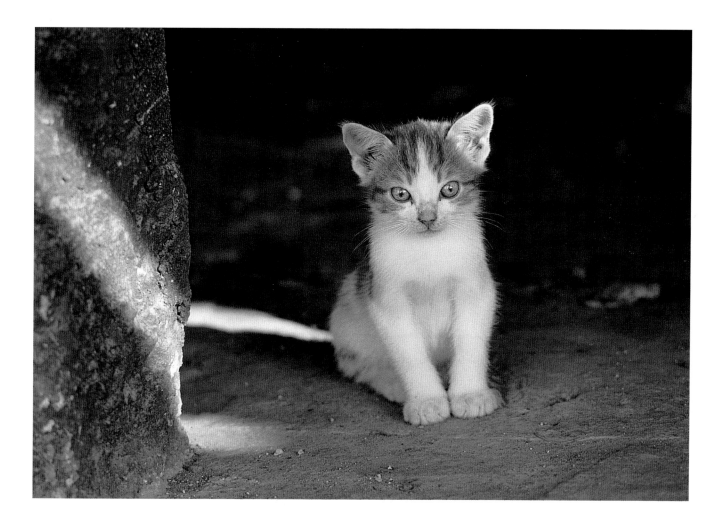

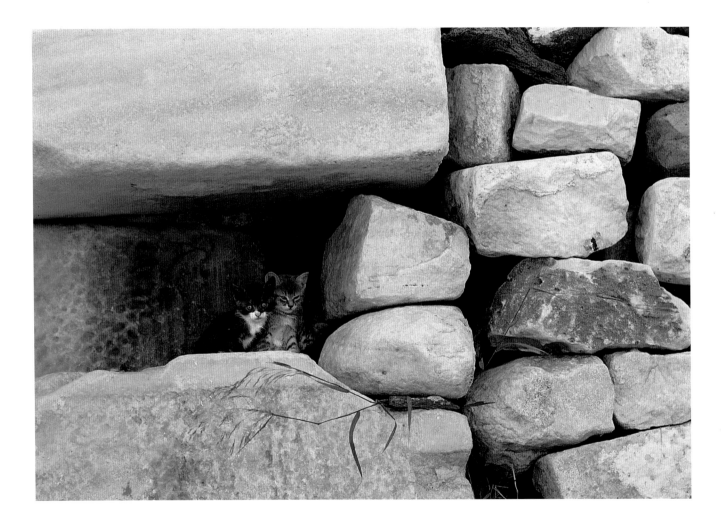

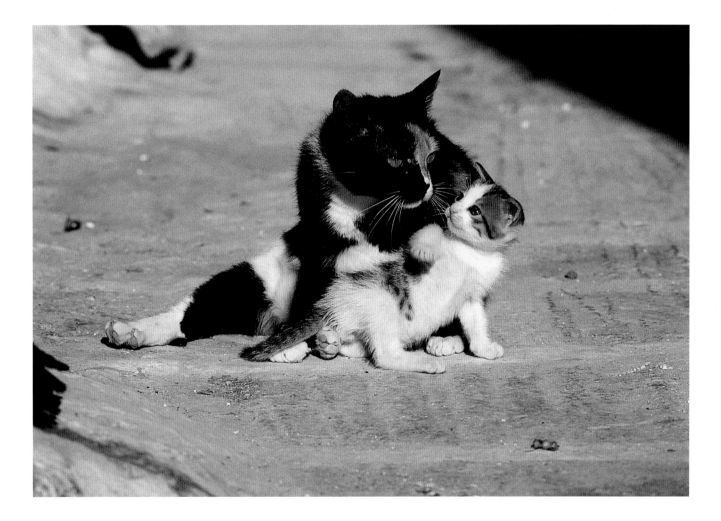

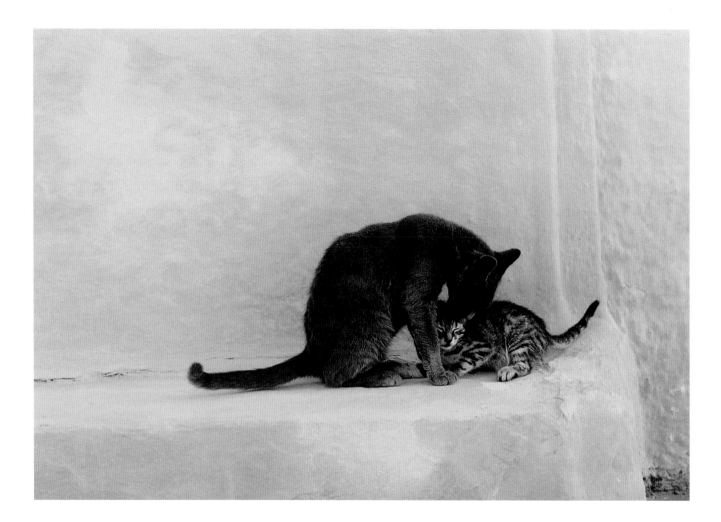

28

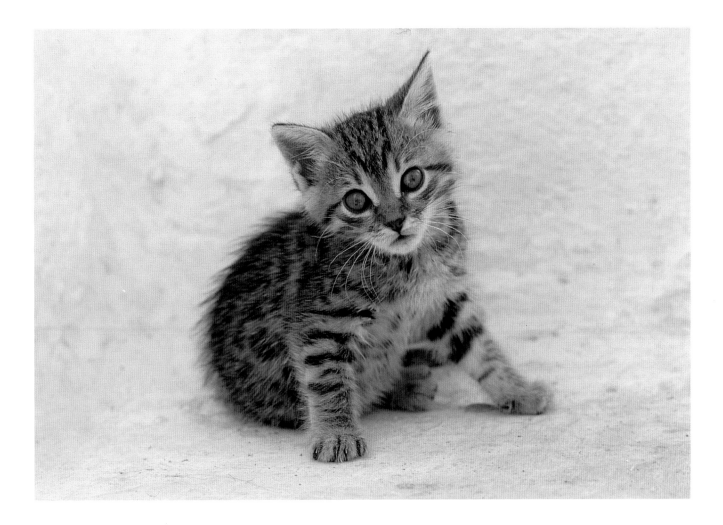

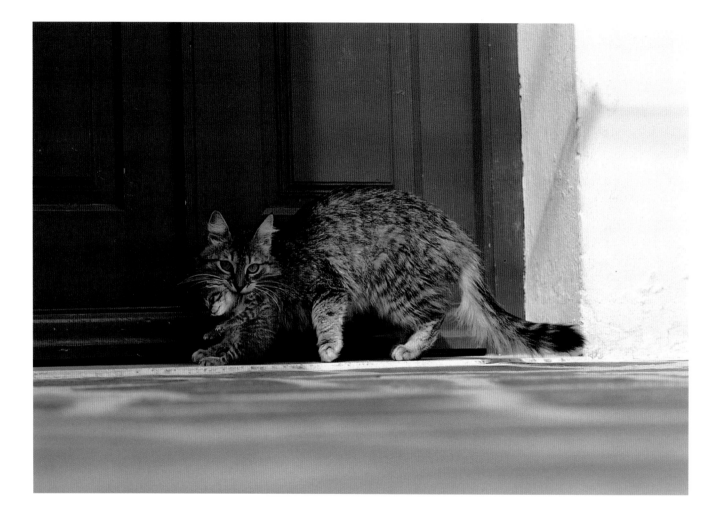

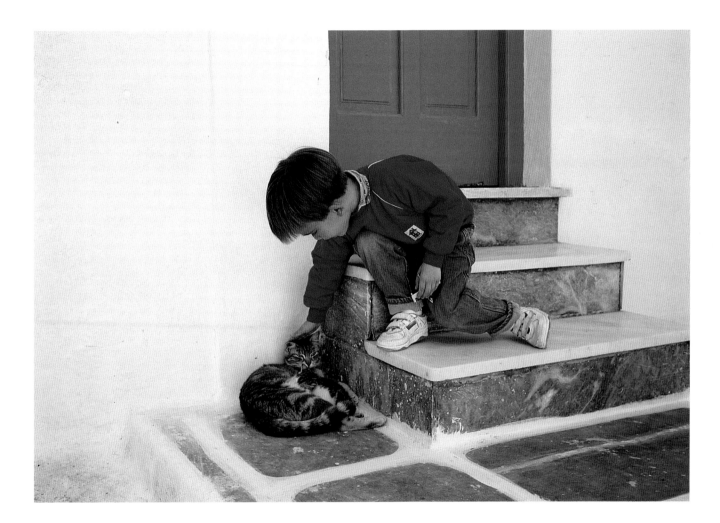

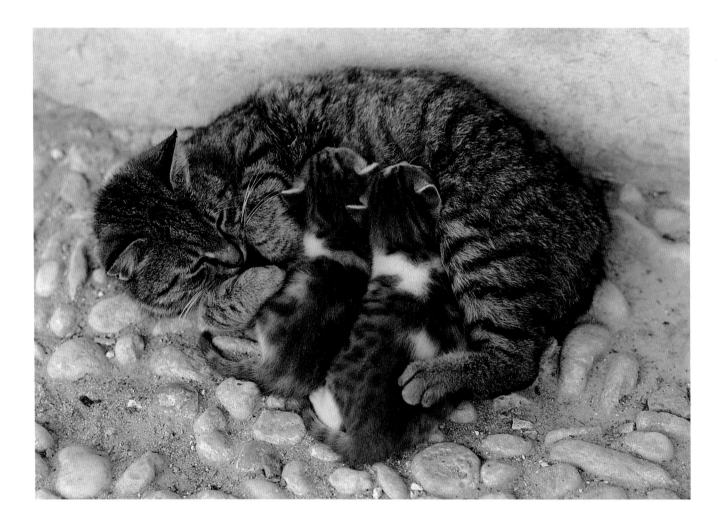

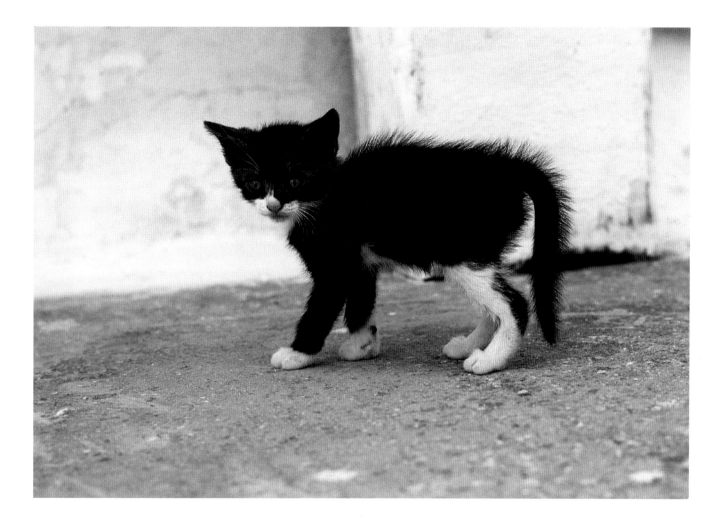

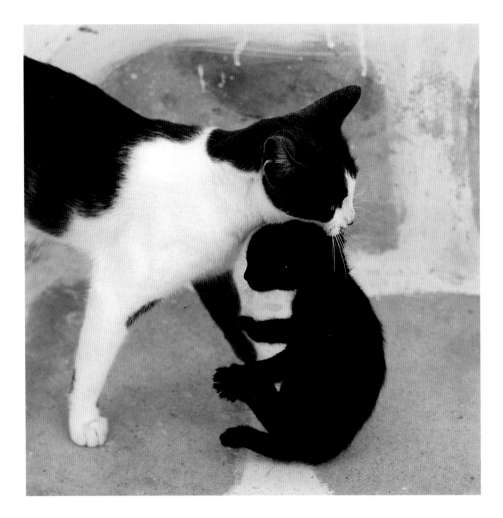

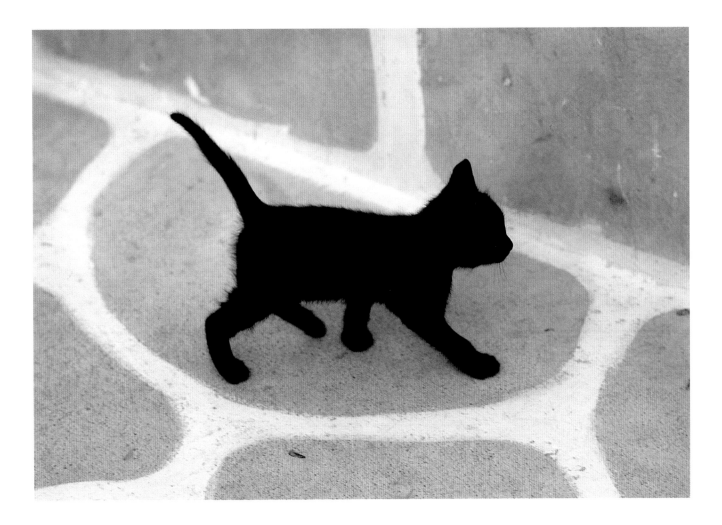

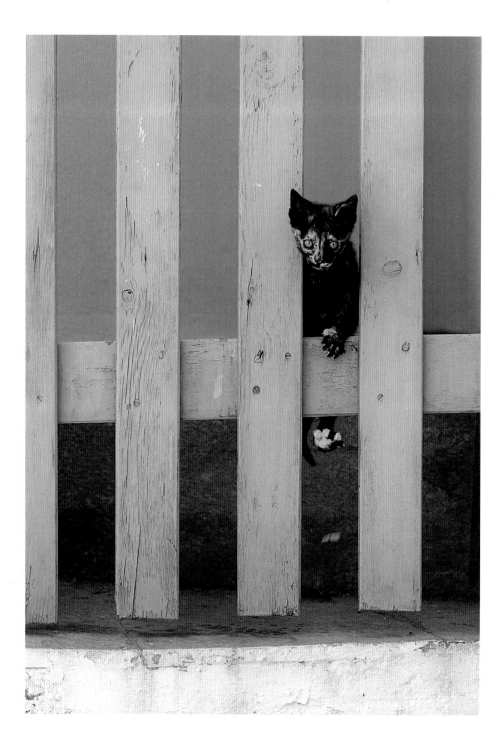

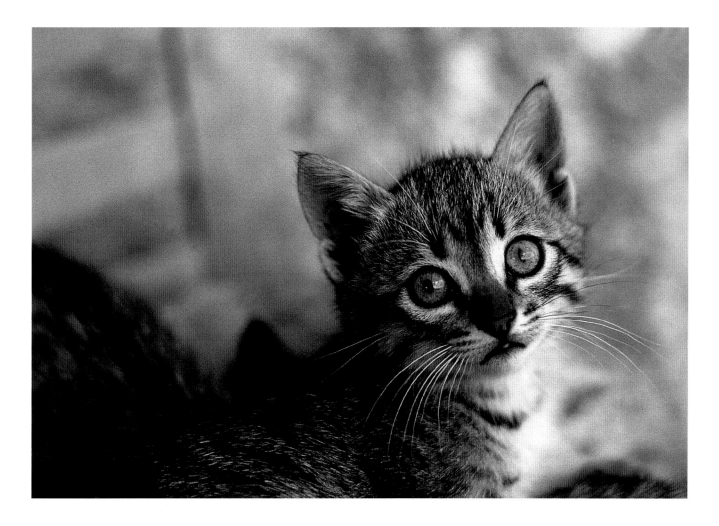

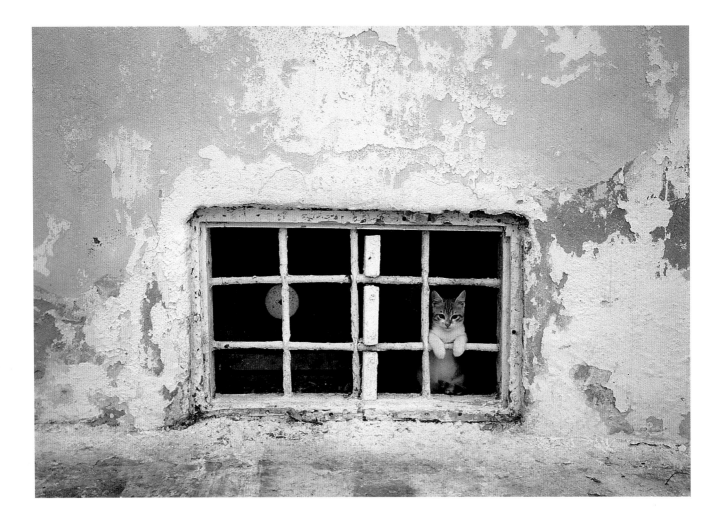

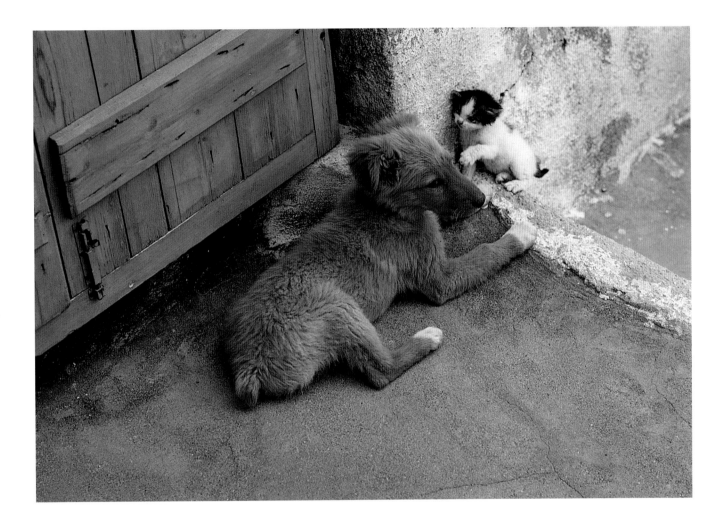

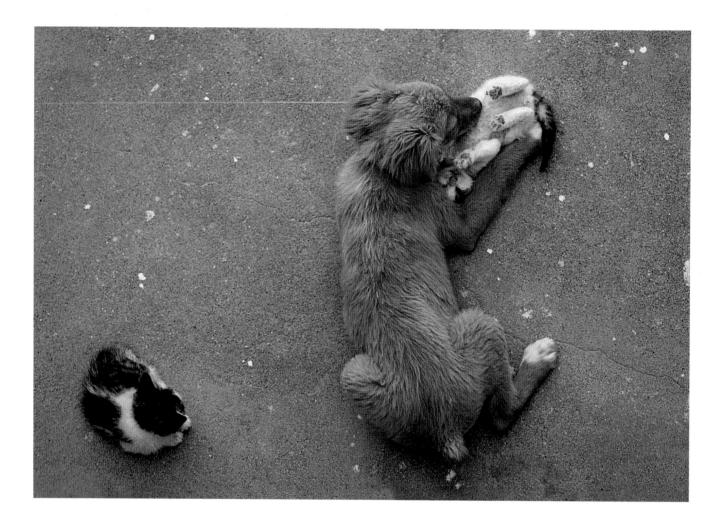

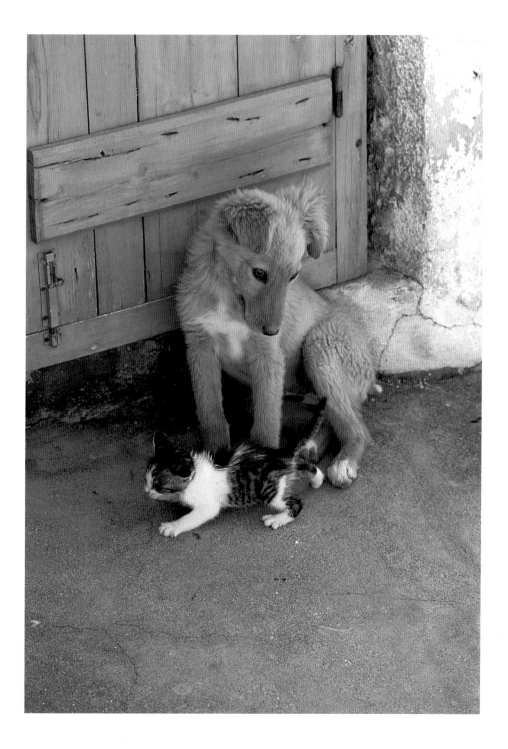

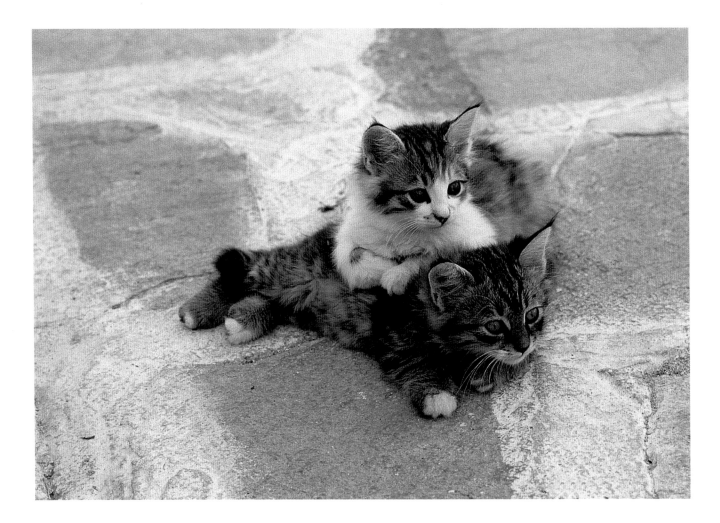

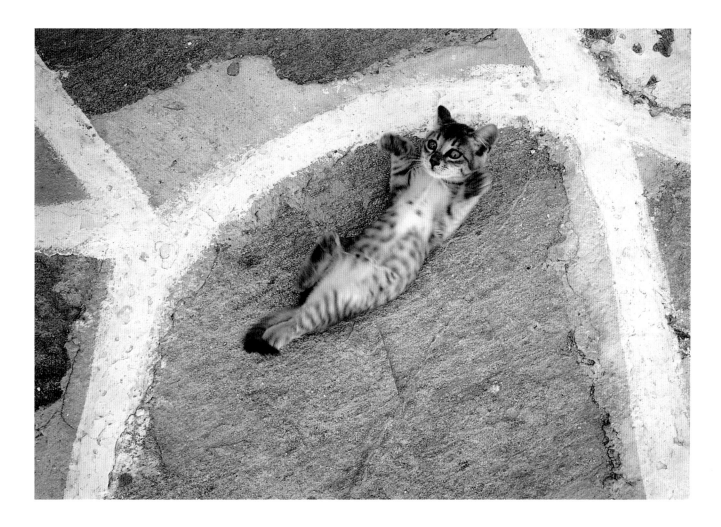

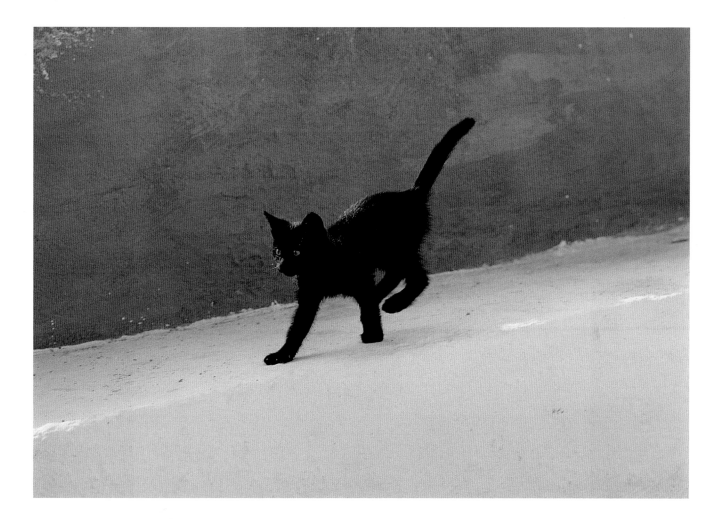

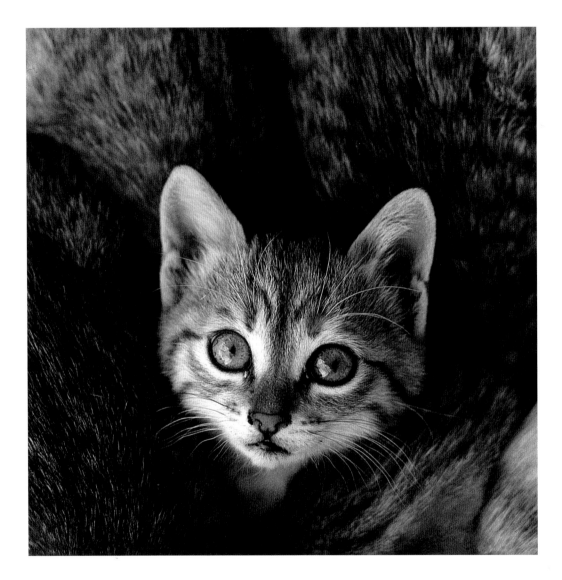

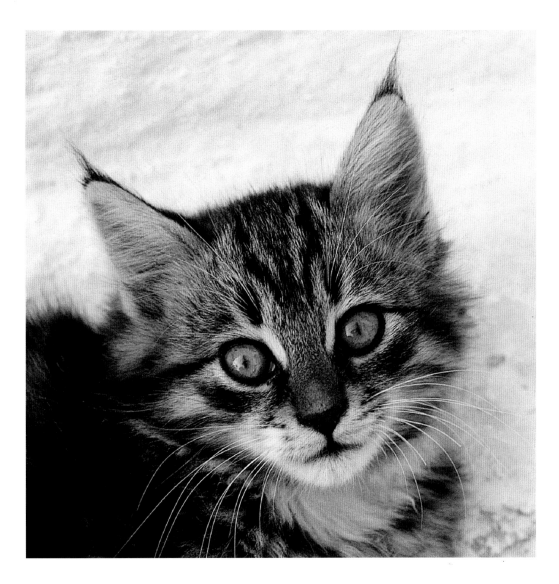

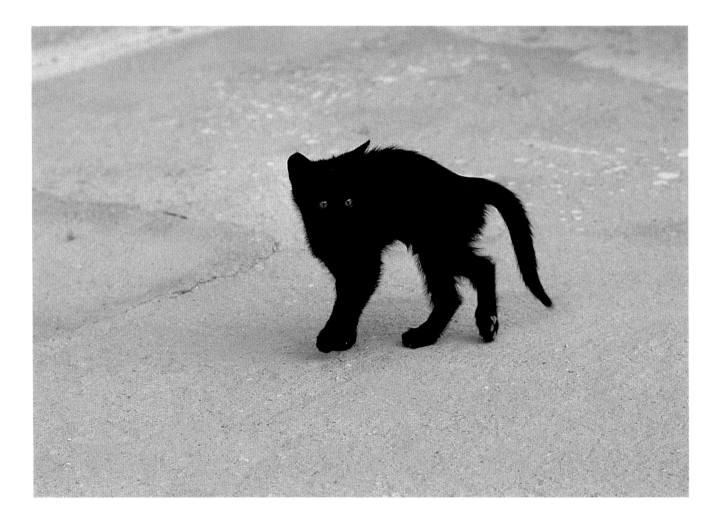

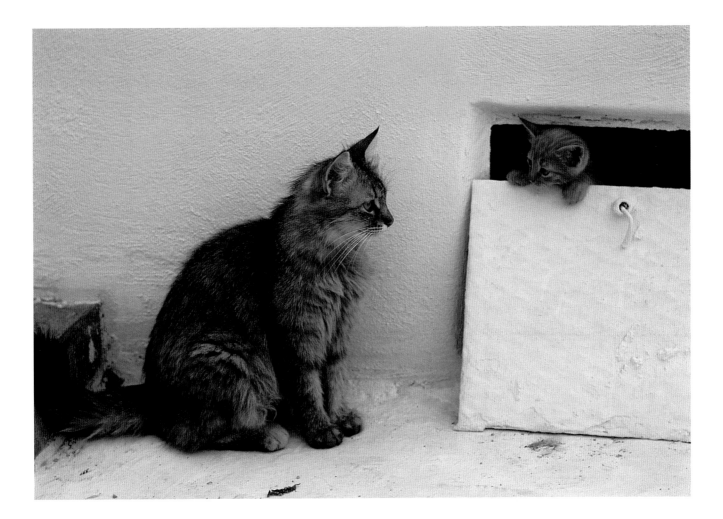

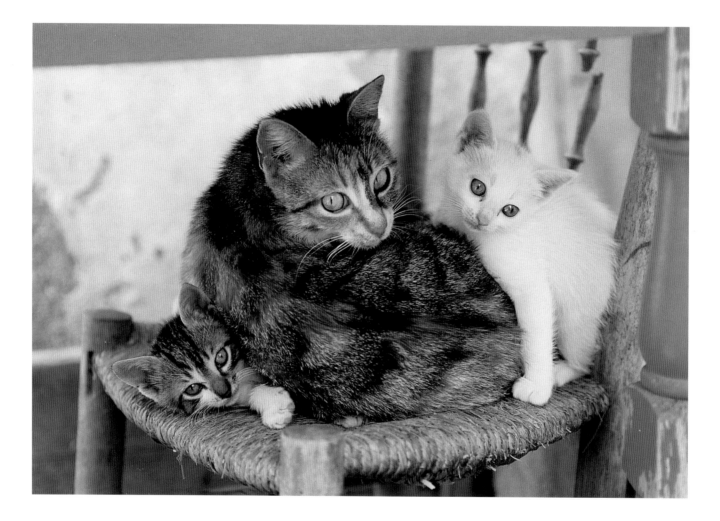

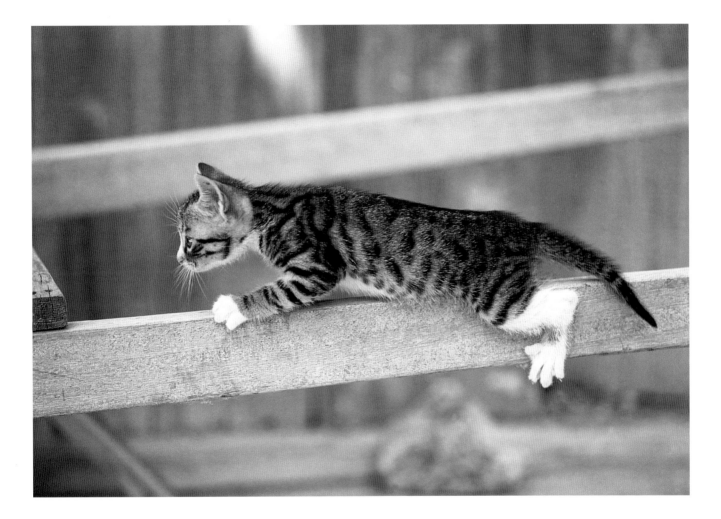

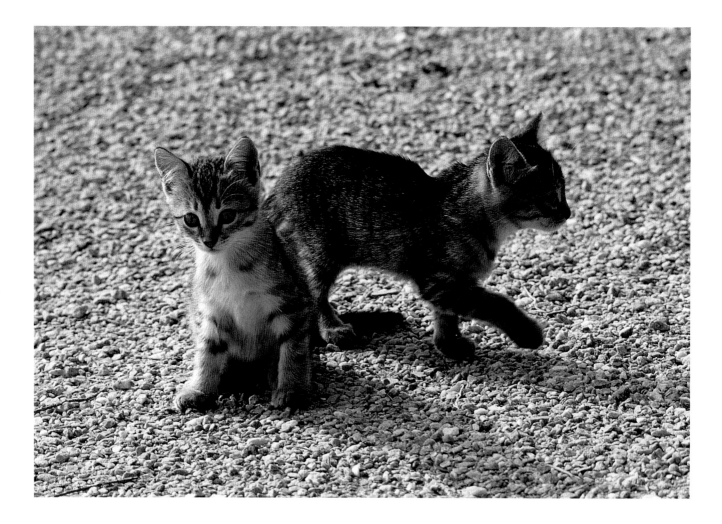

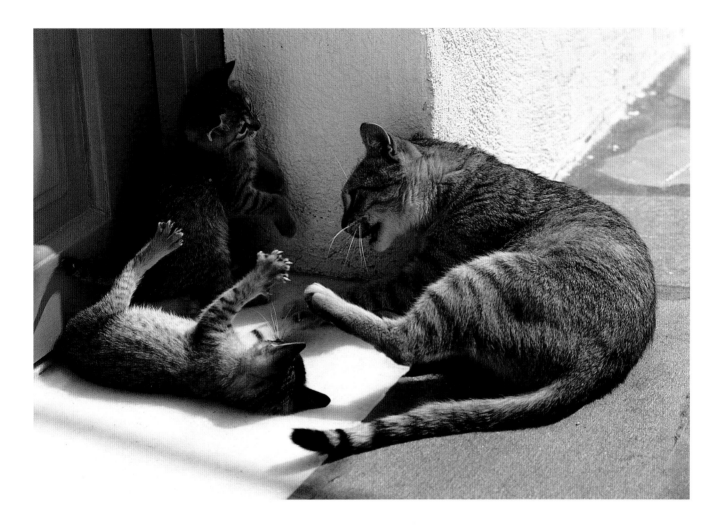

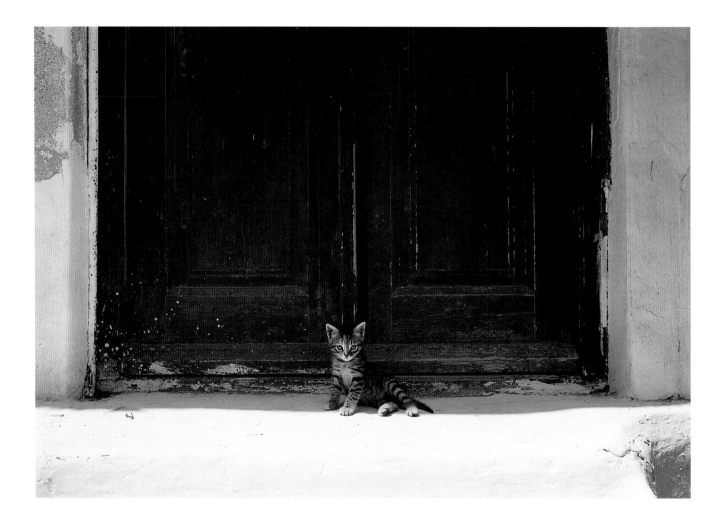

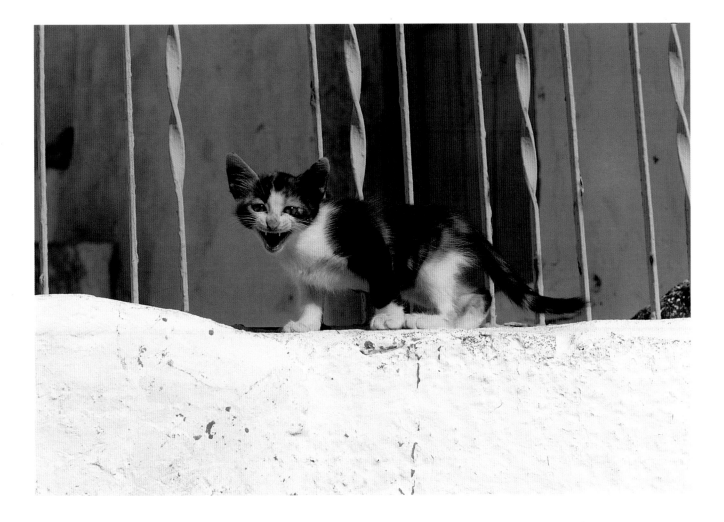

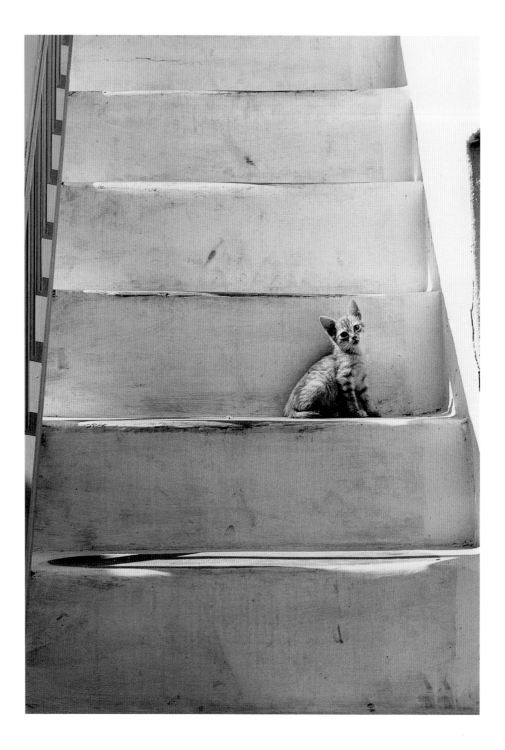

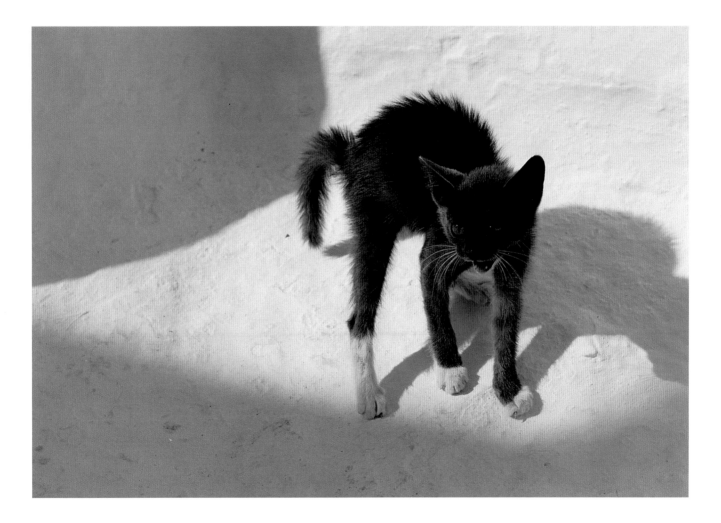

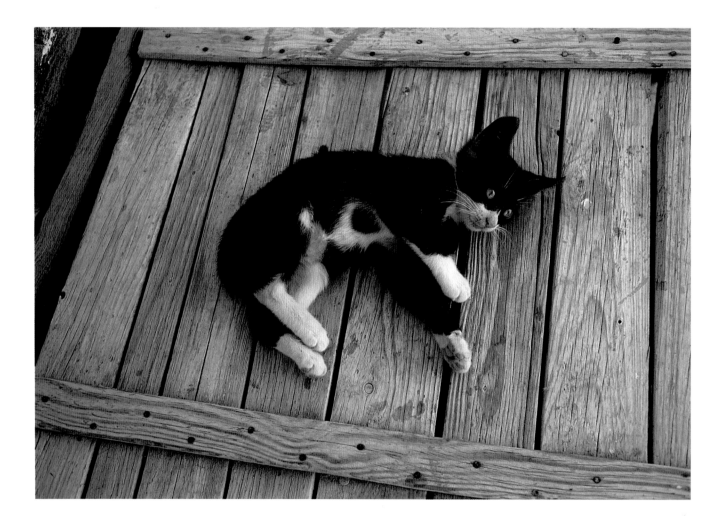

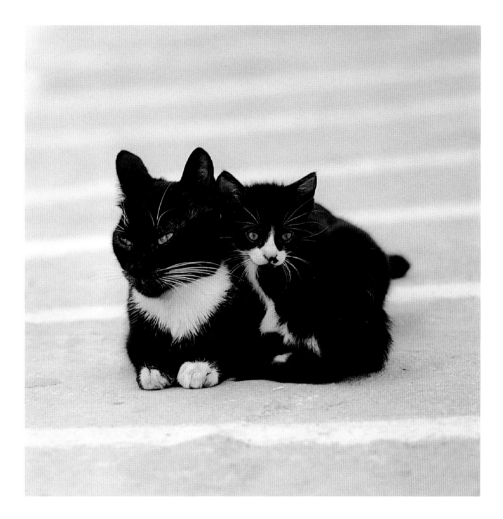

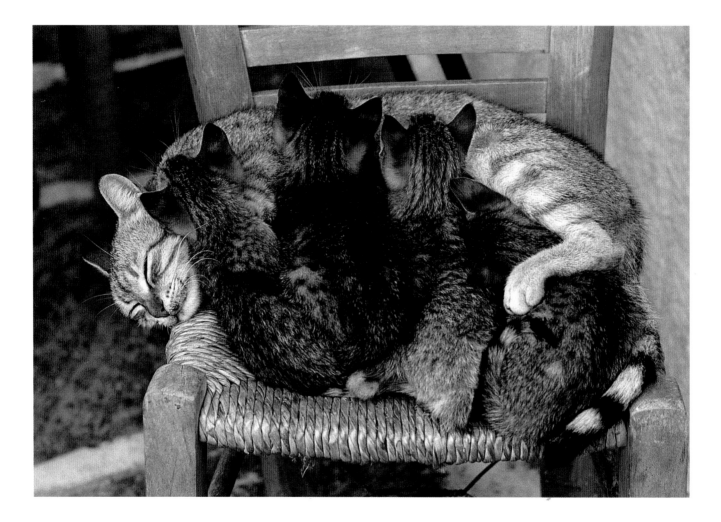

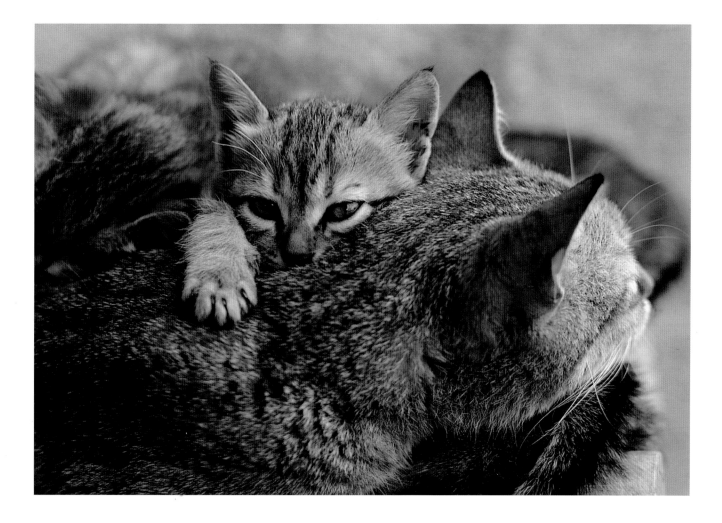

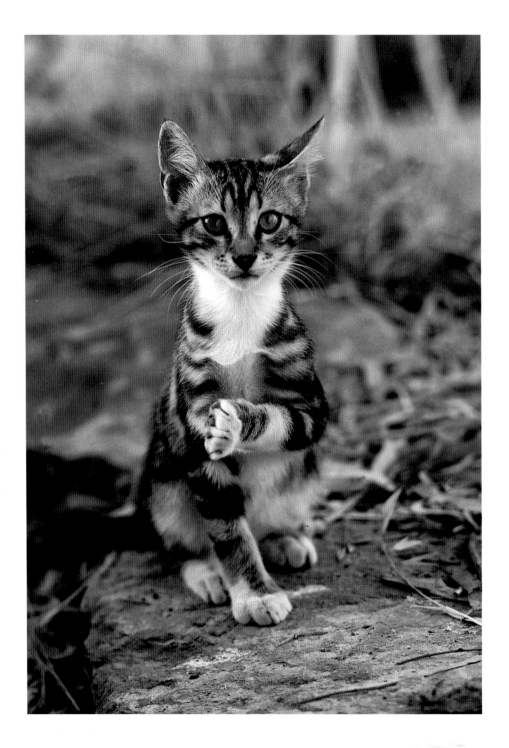

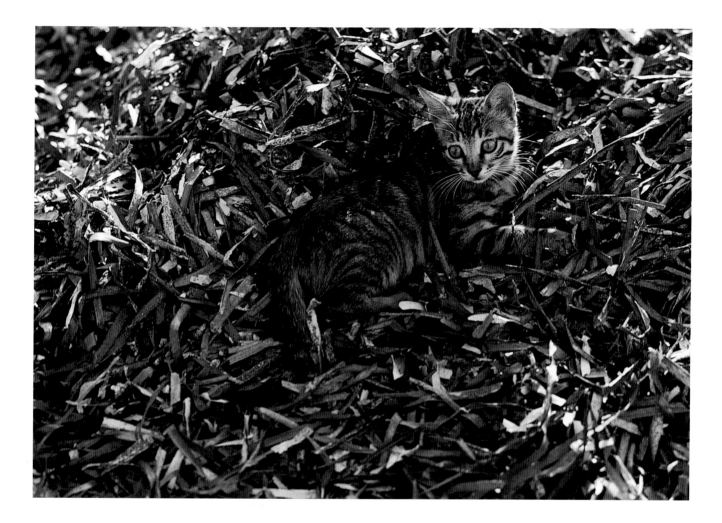

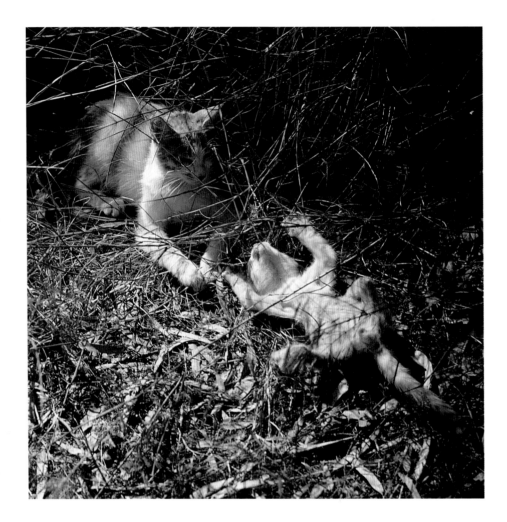

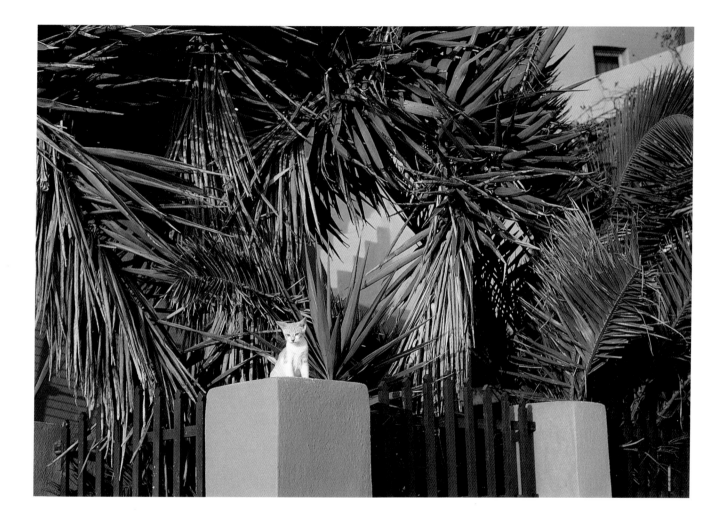

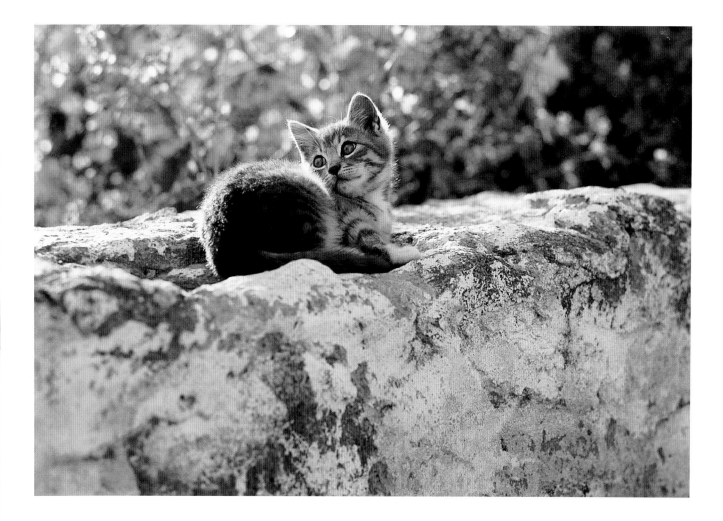

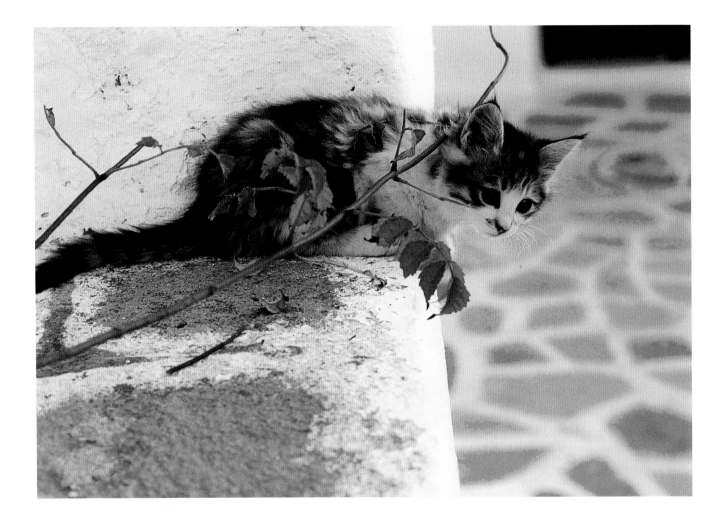

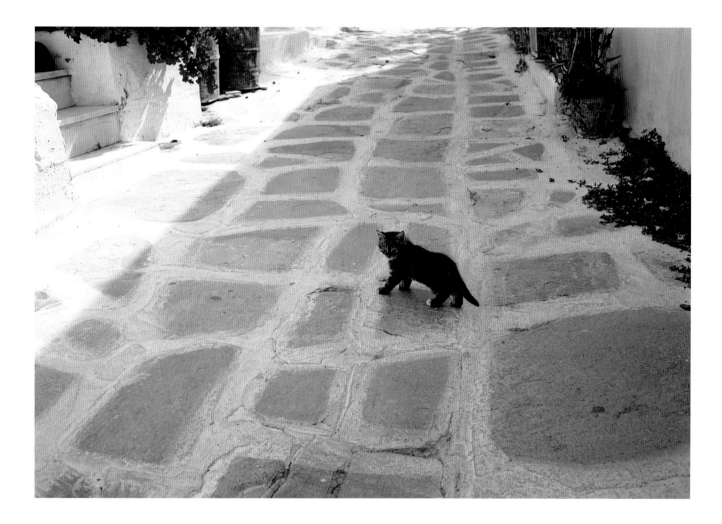

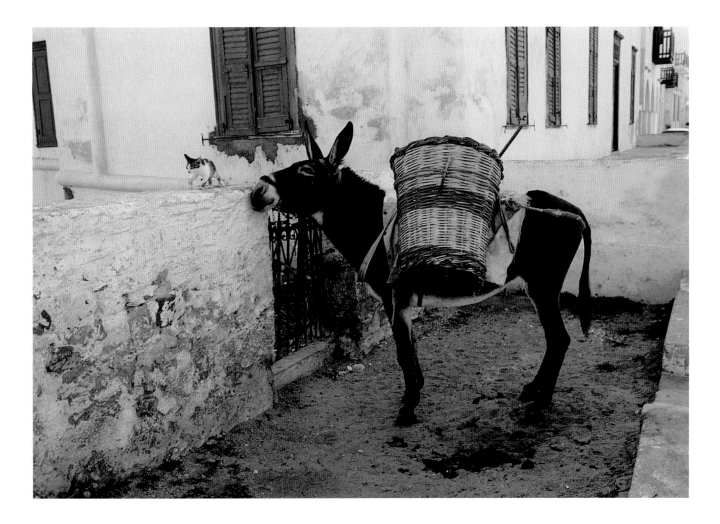

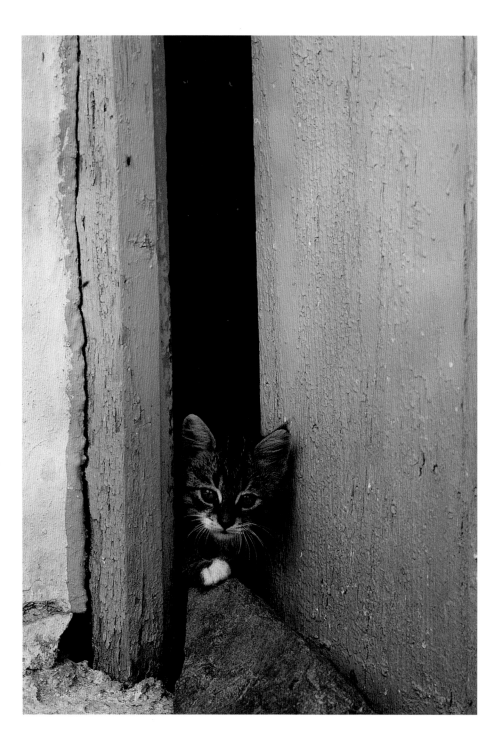

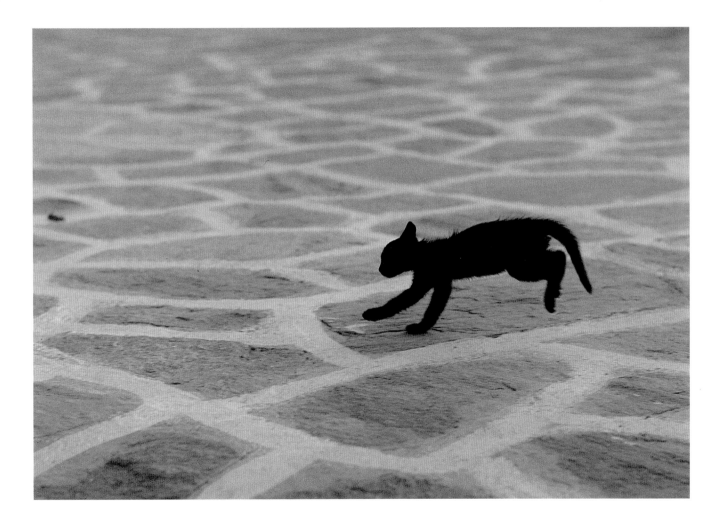

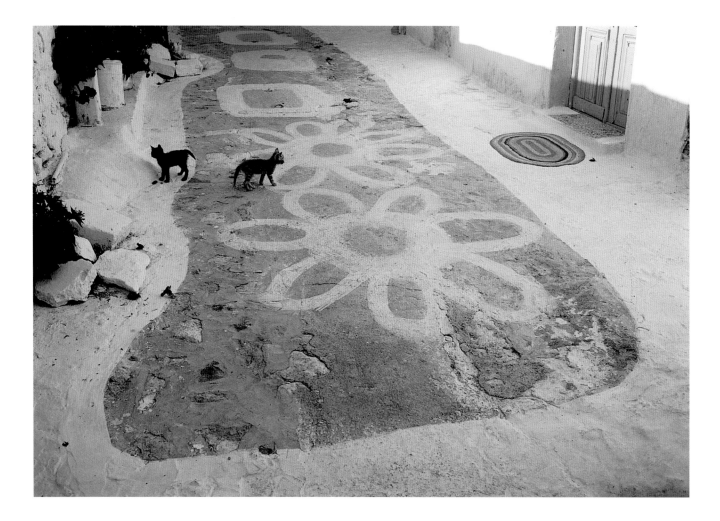

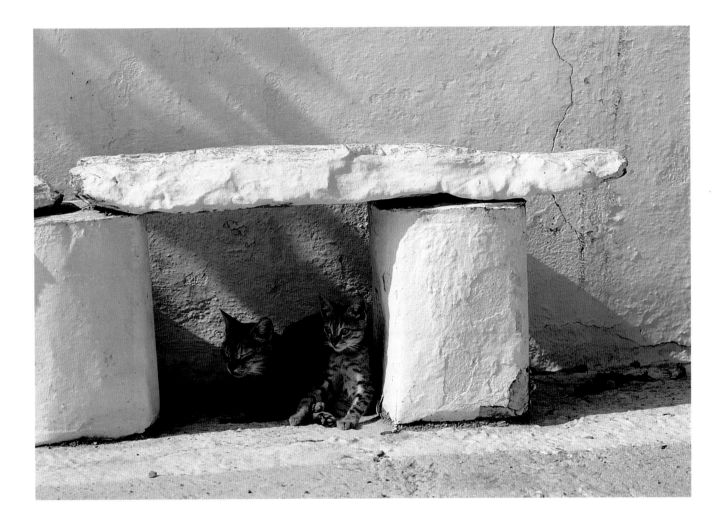

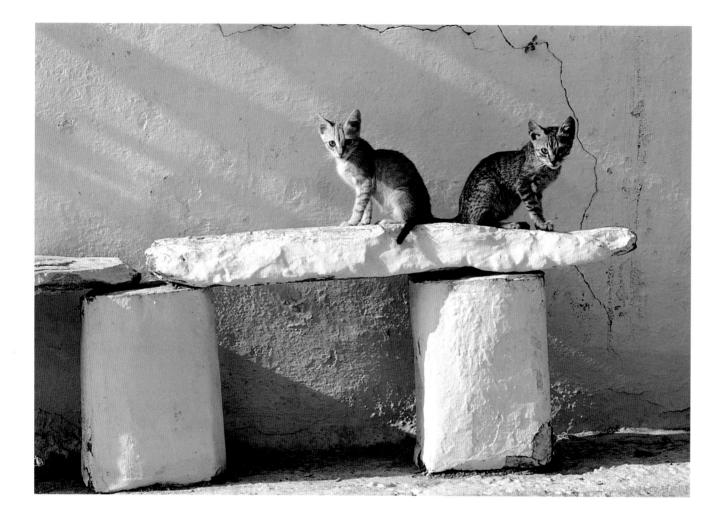

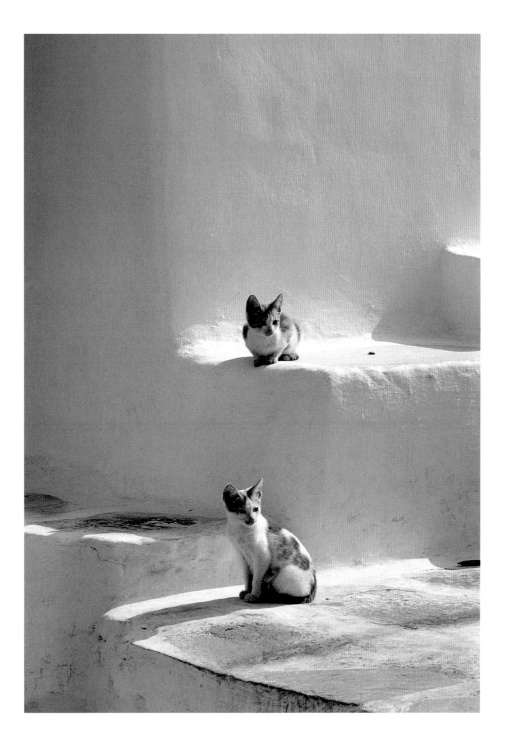

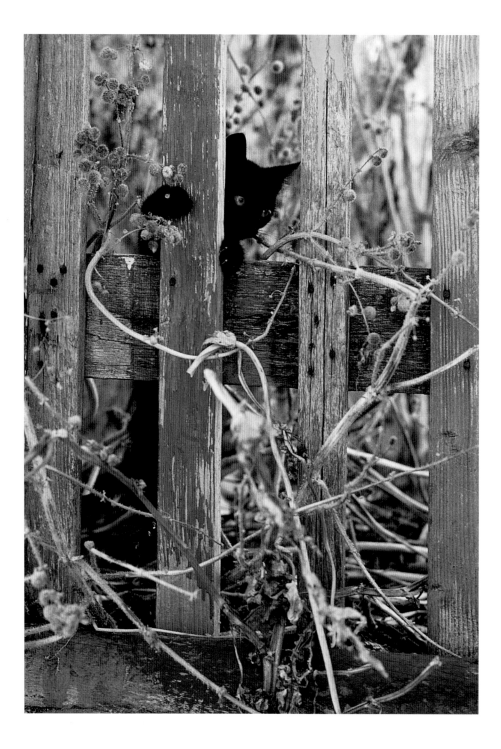

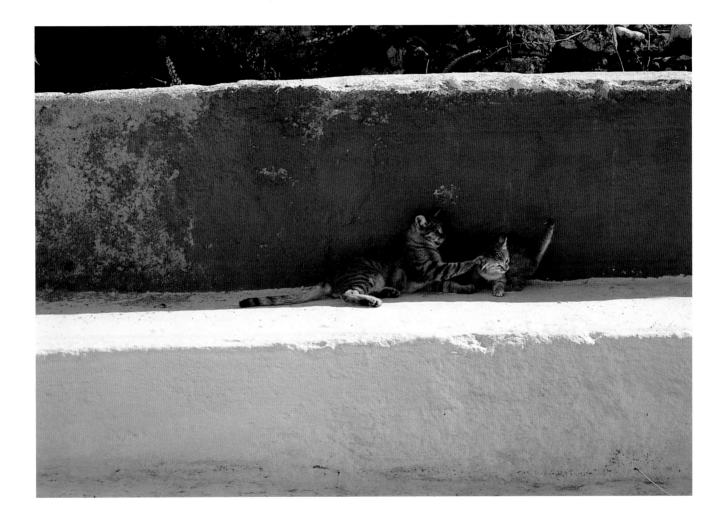

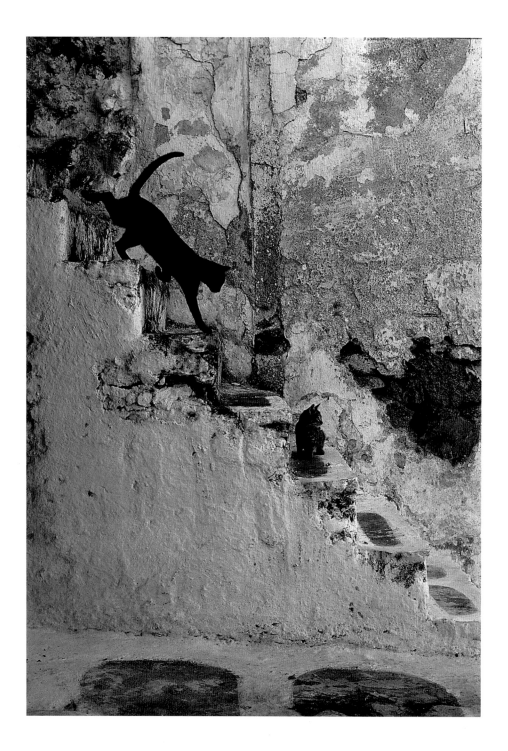

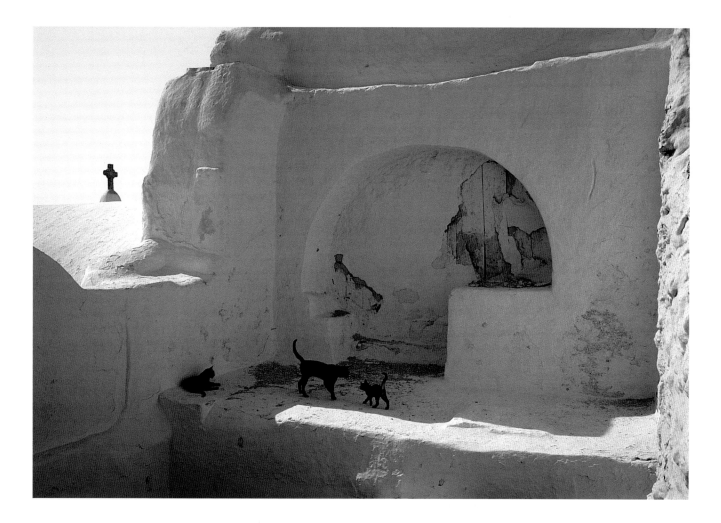

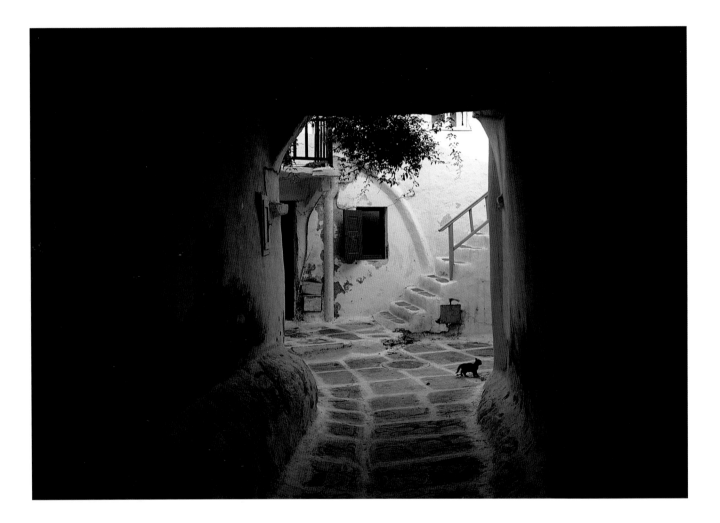

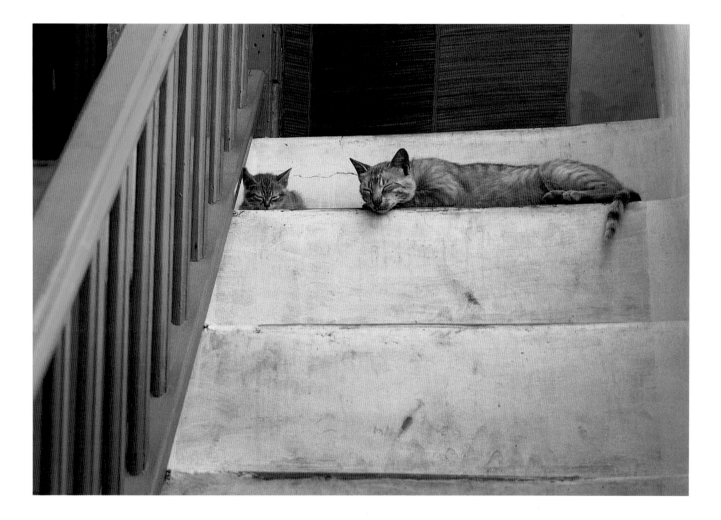

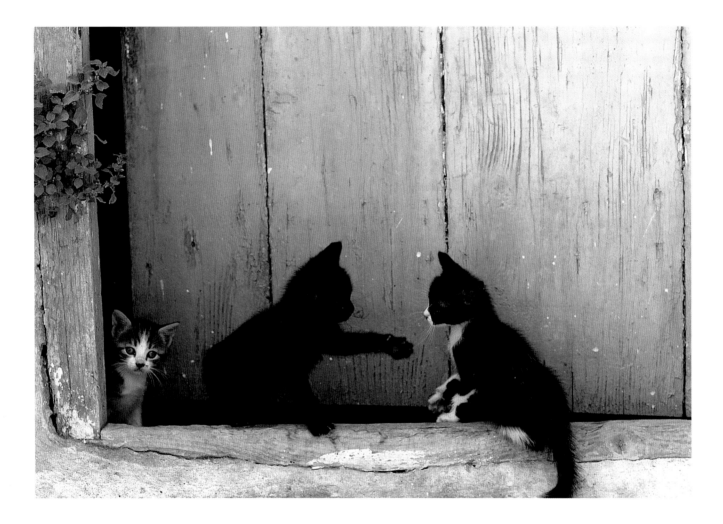

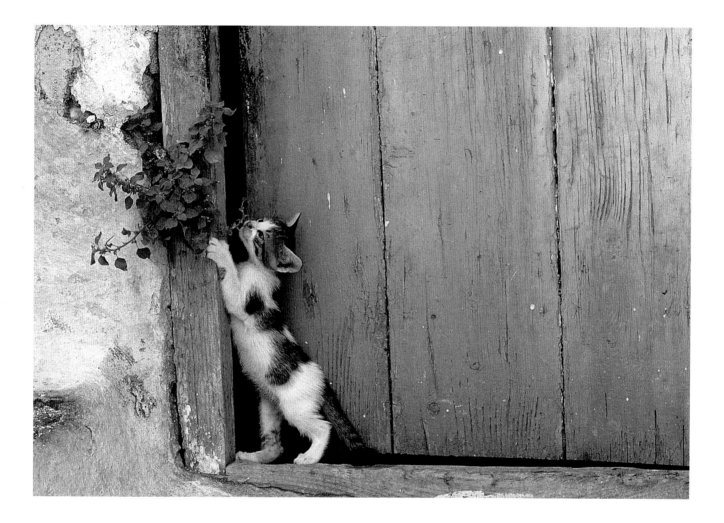

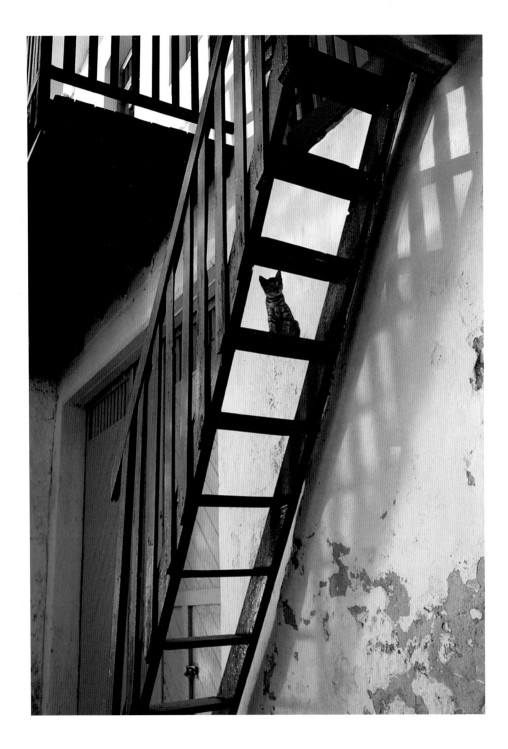

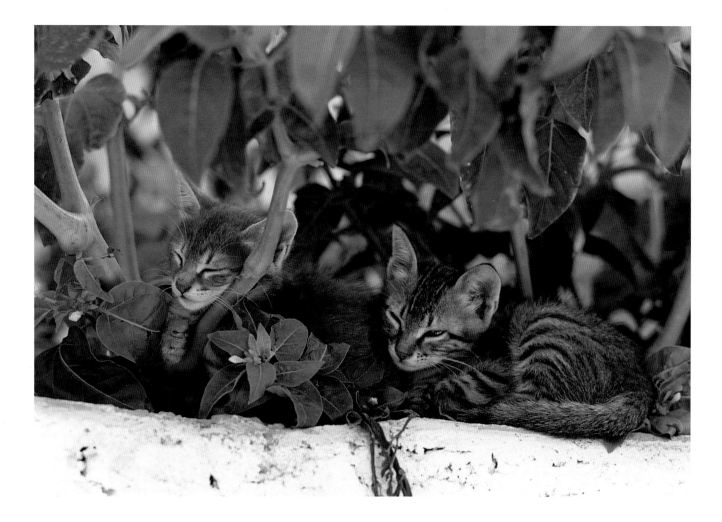

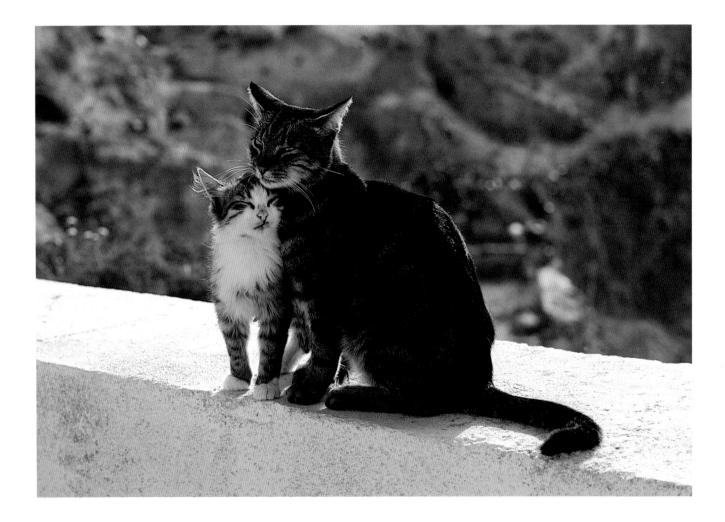

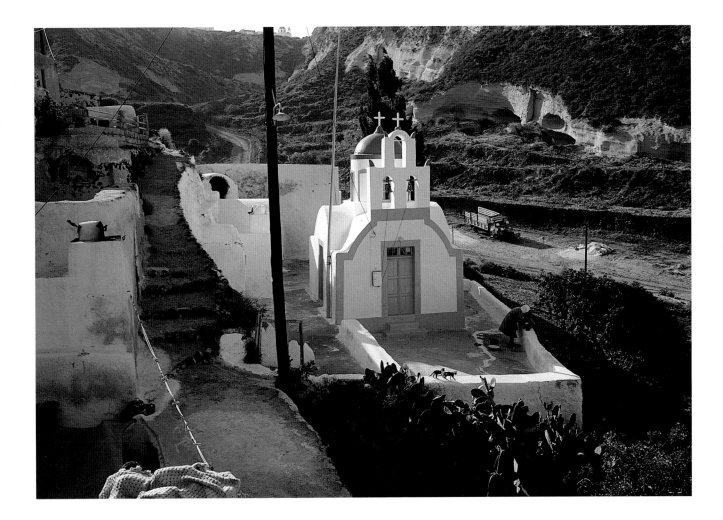

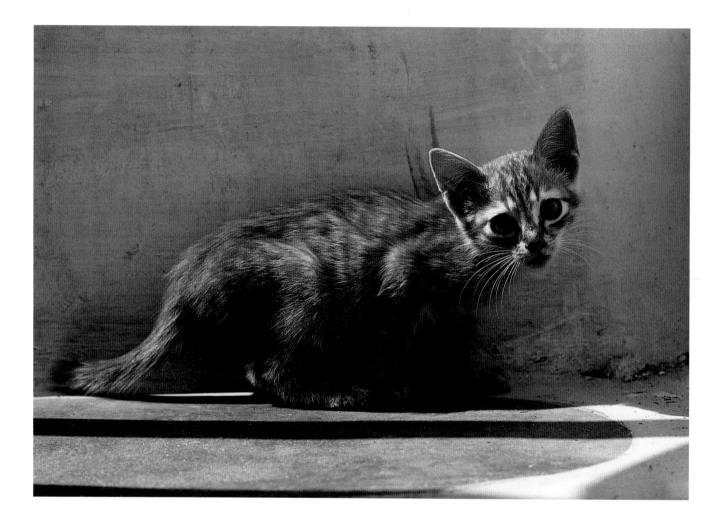

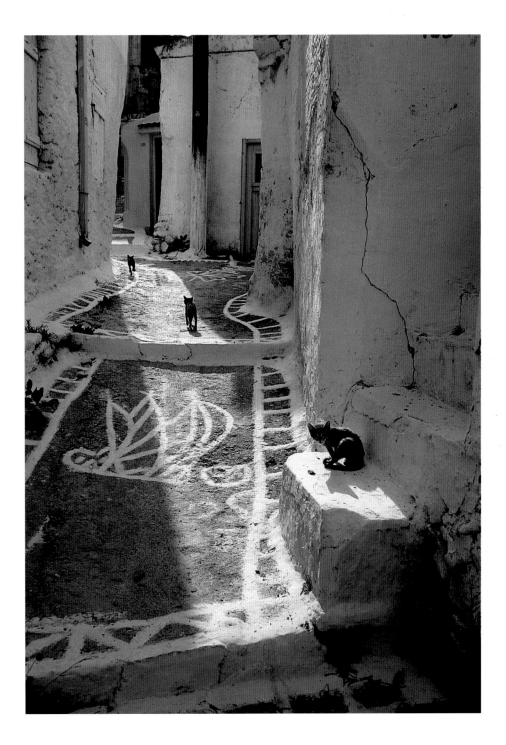

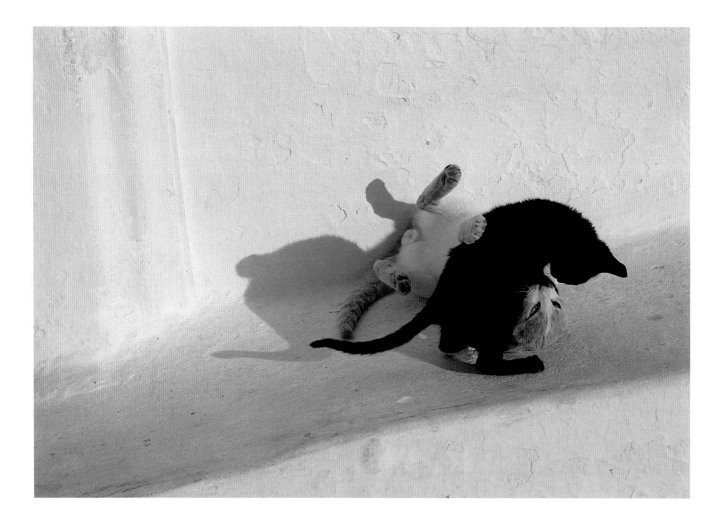

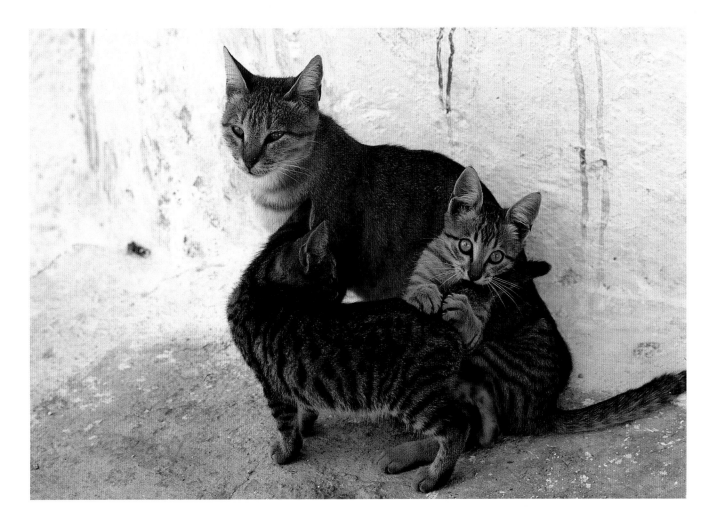

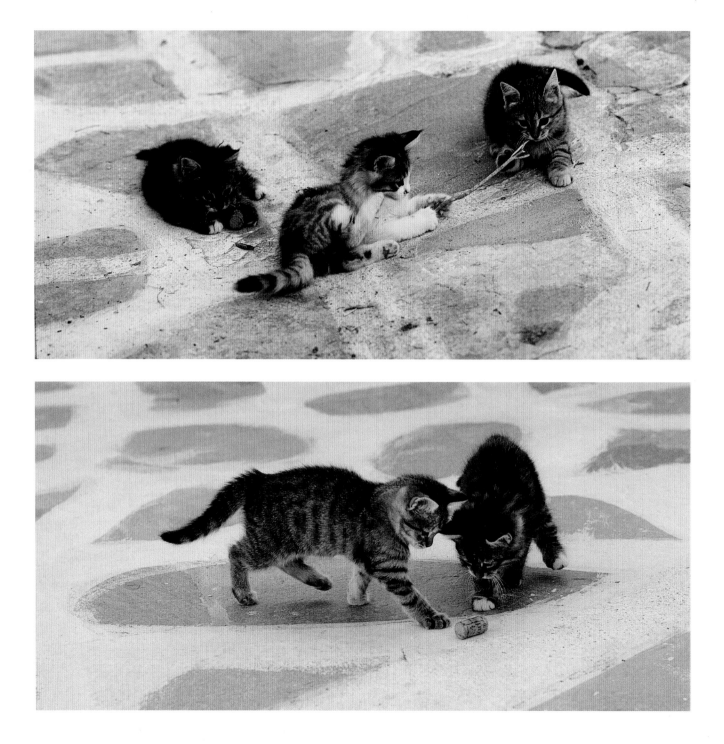

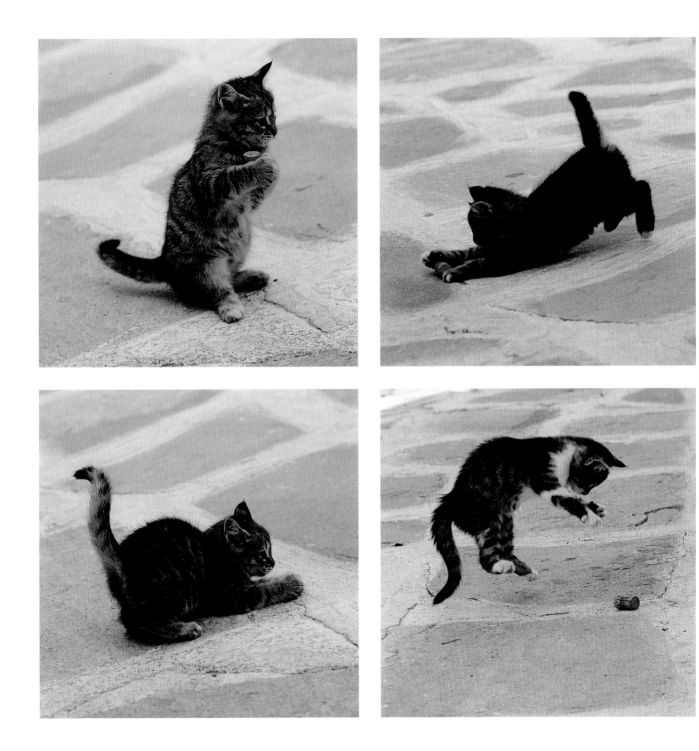

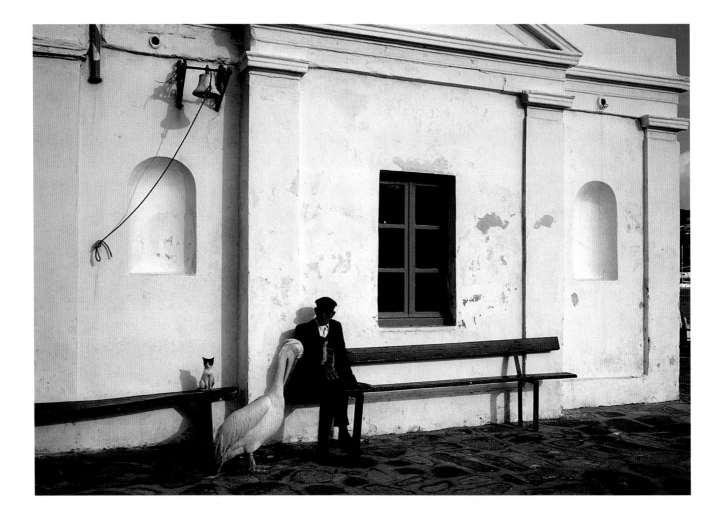

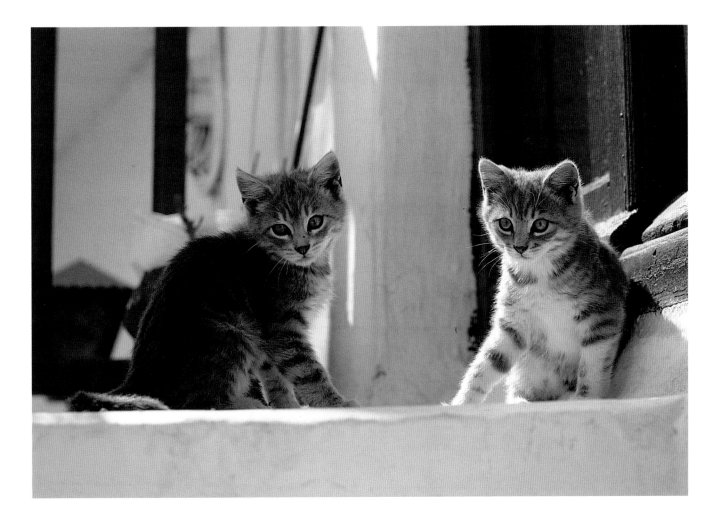

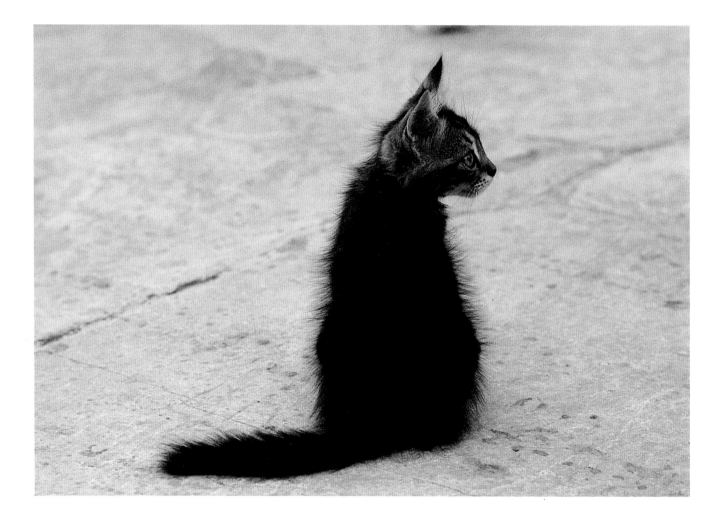

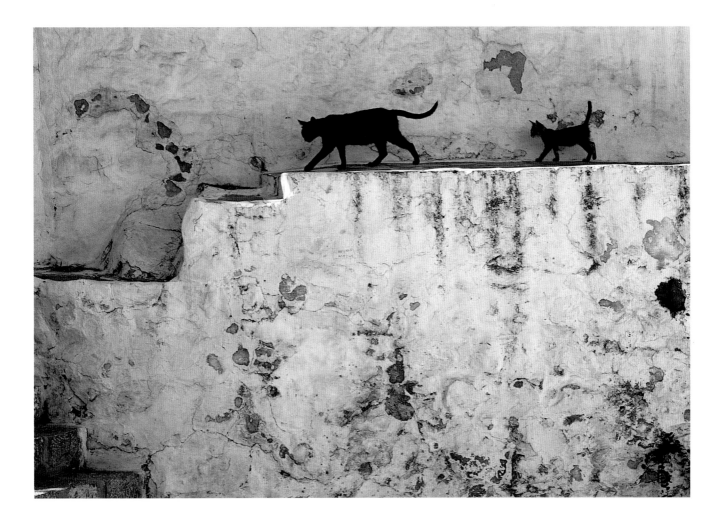

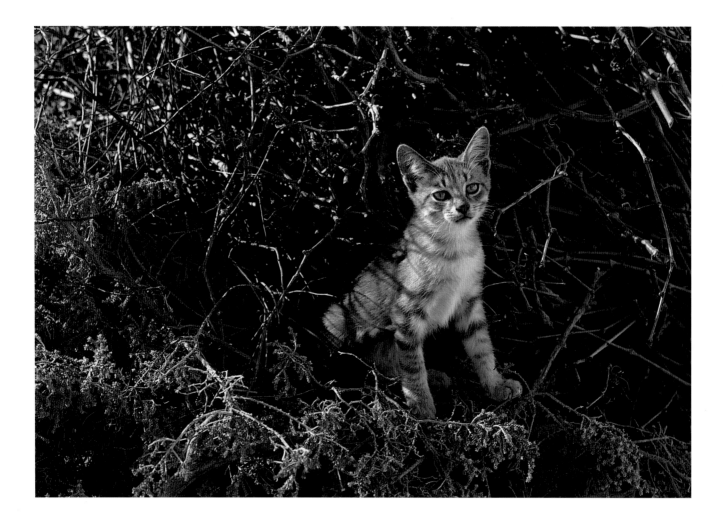

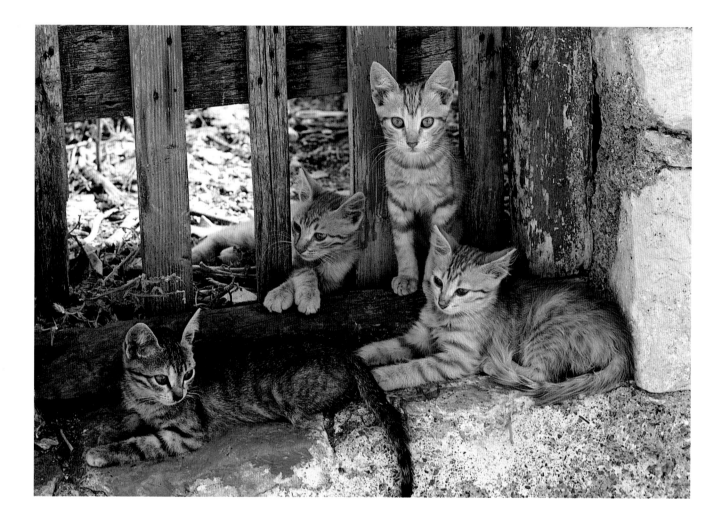

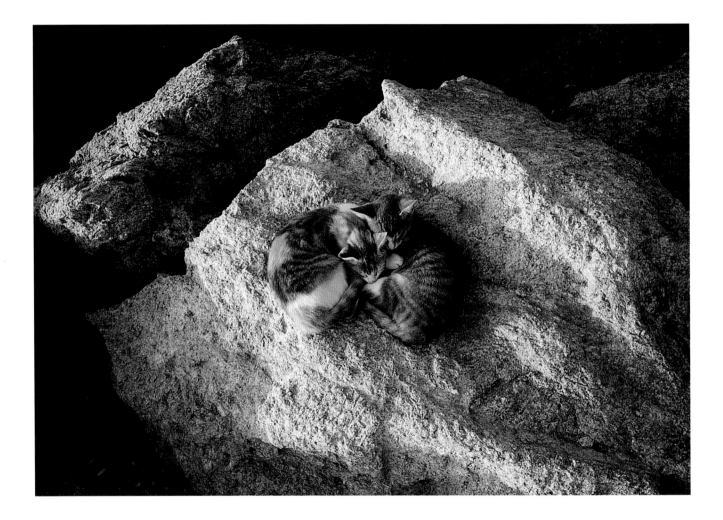

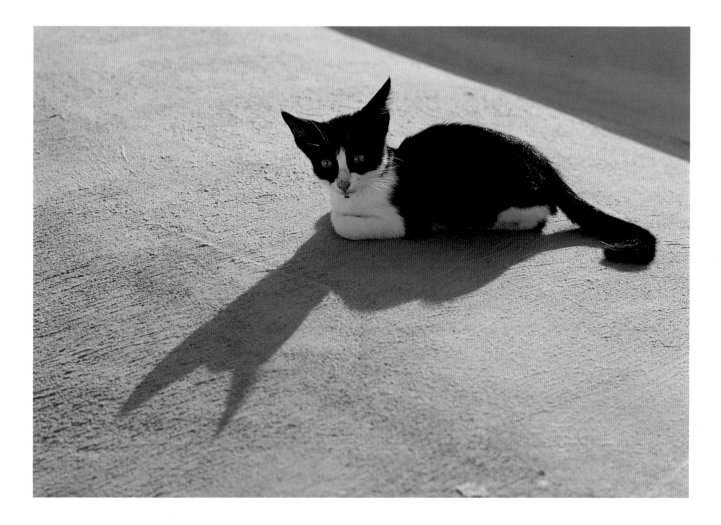

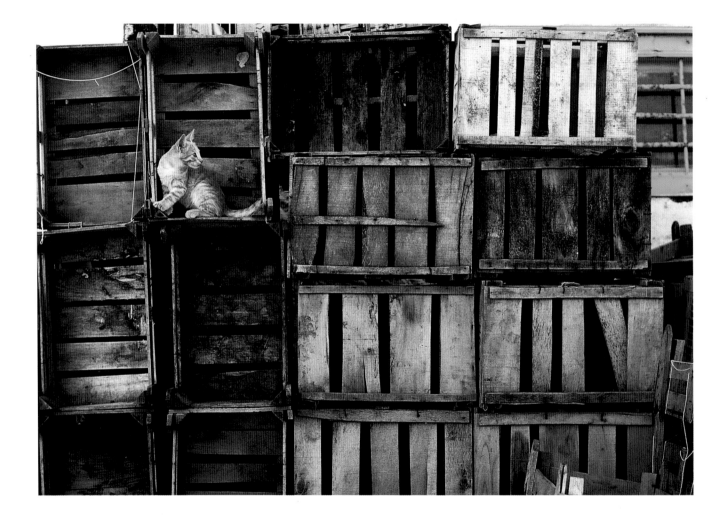

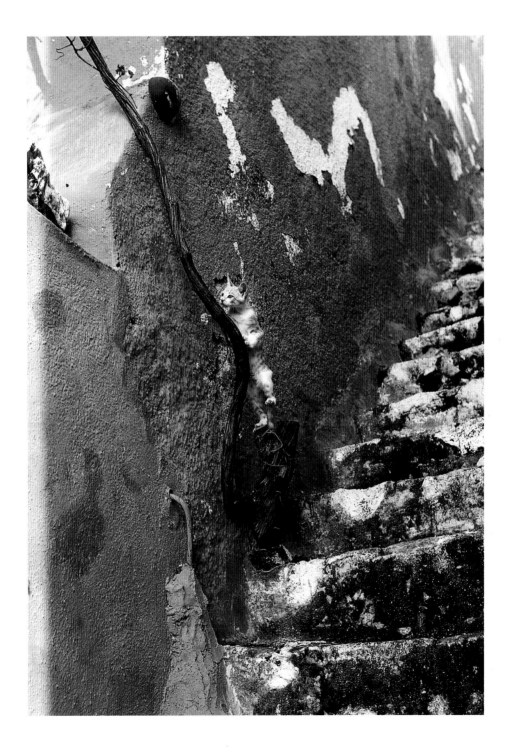

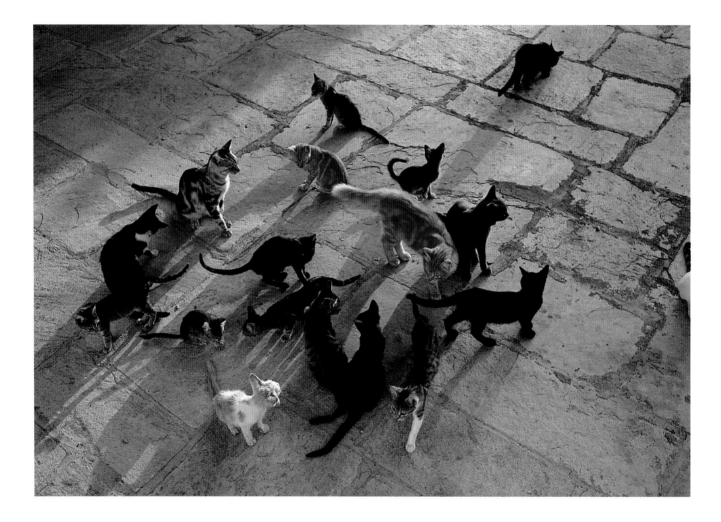

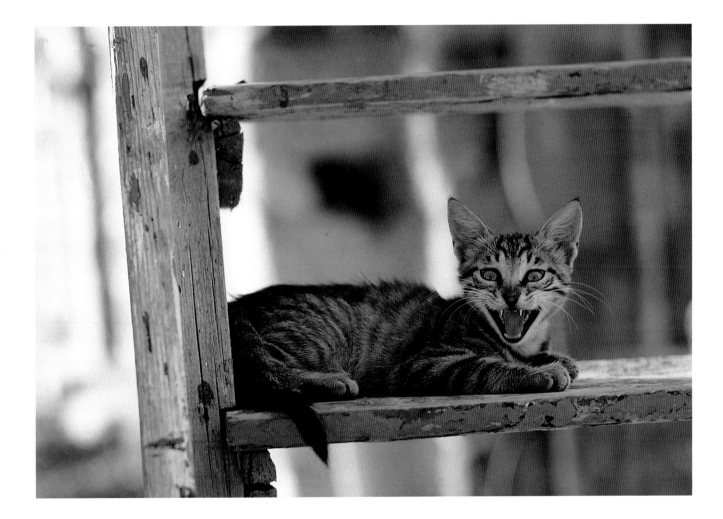

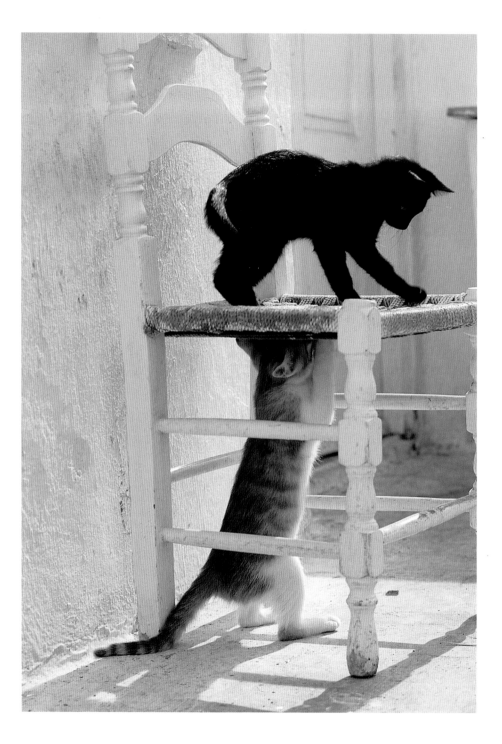

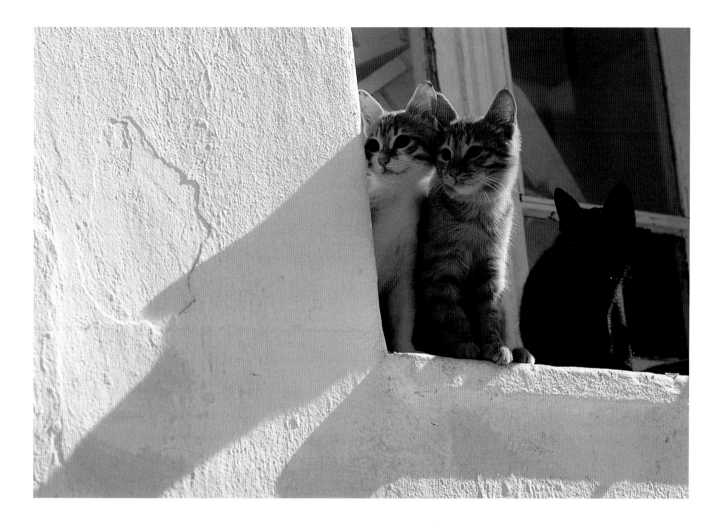

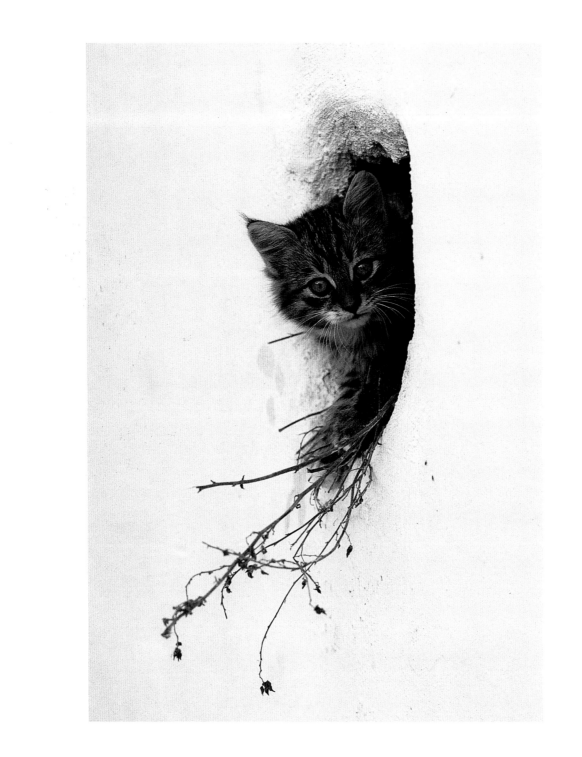

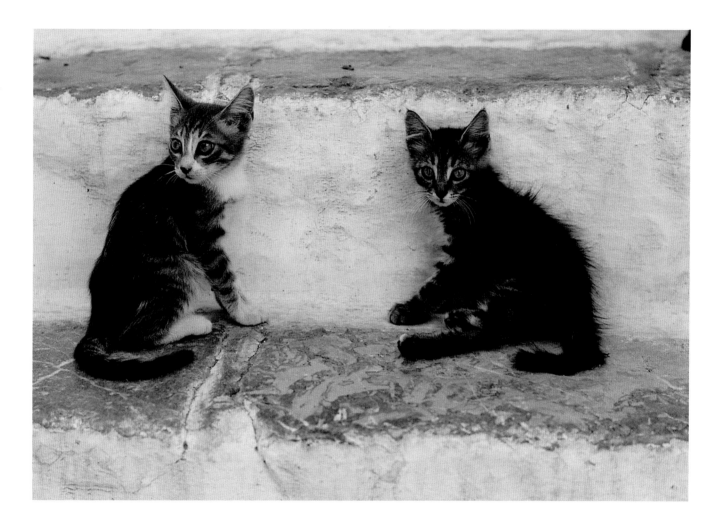

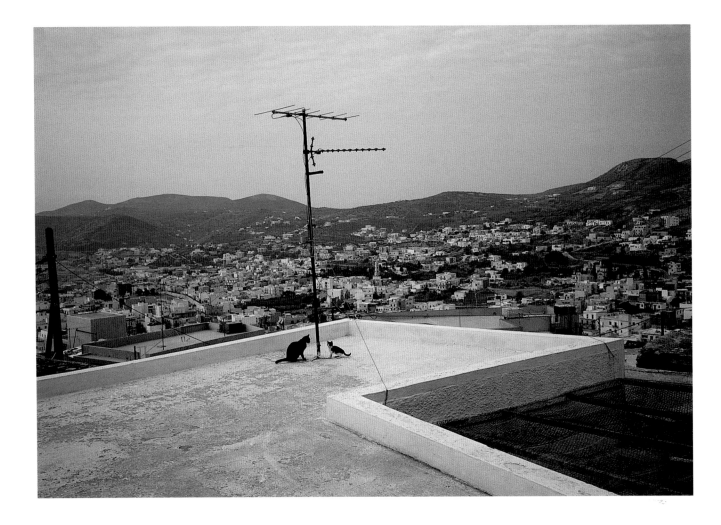

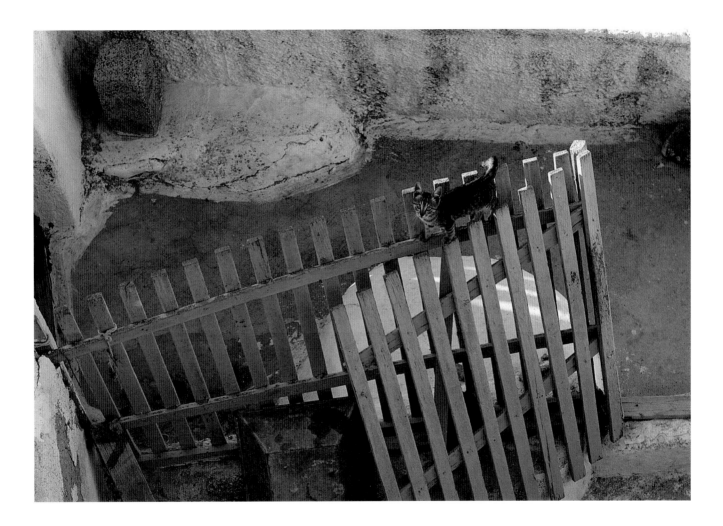

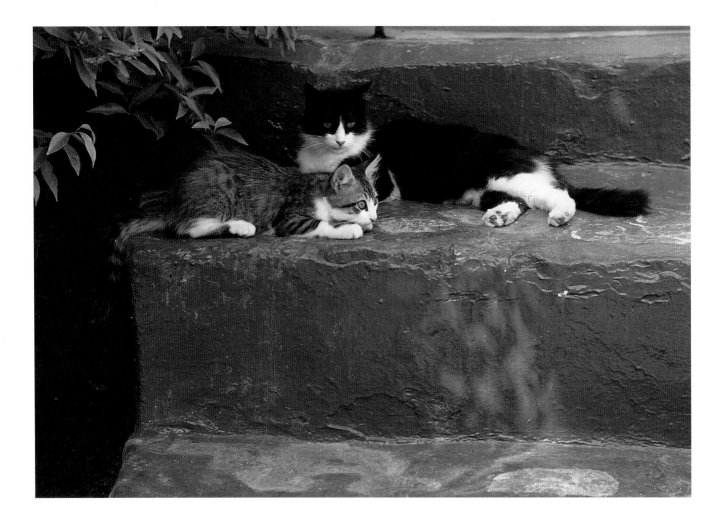

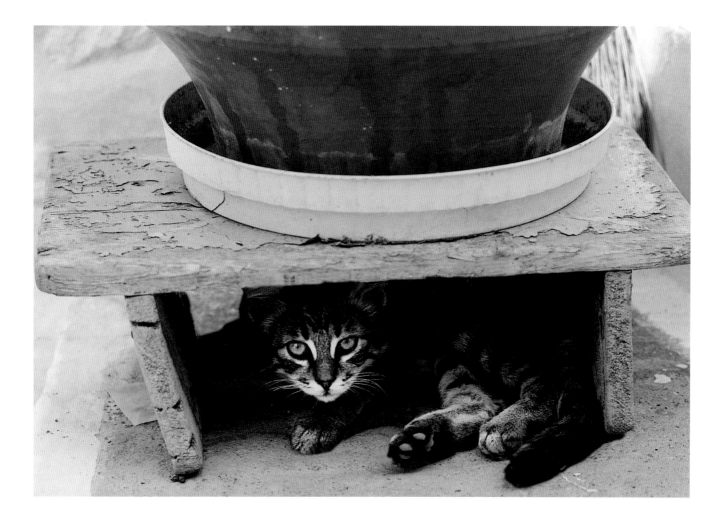

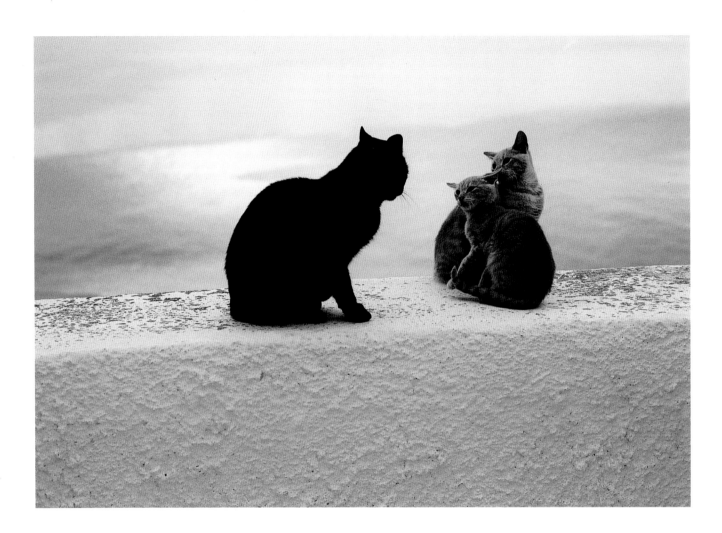

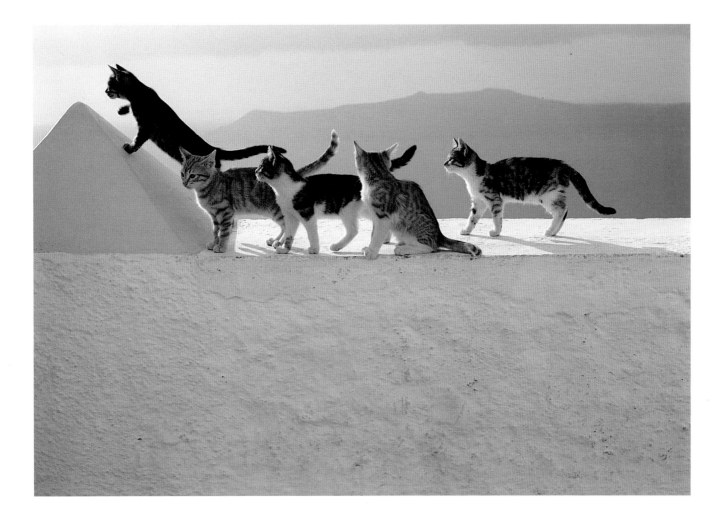

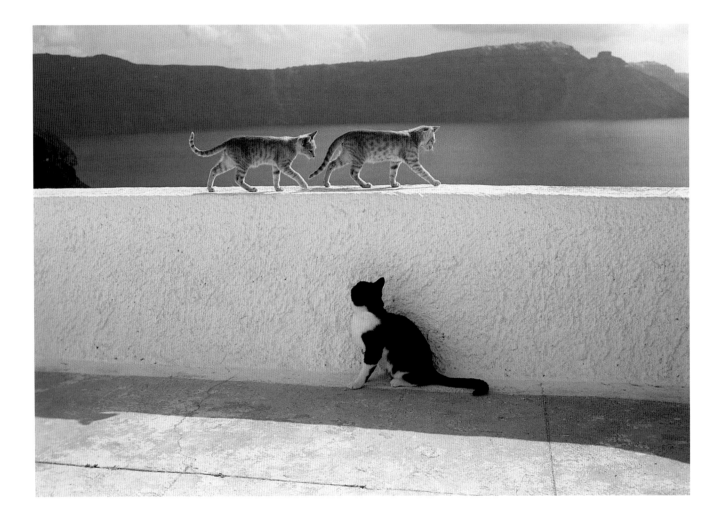

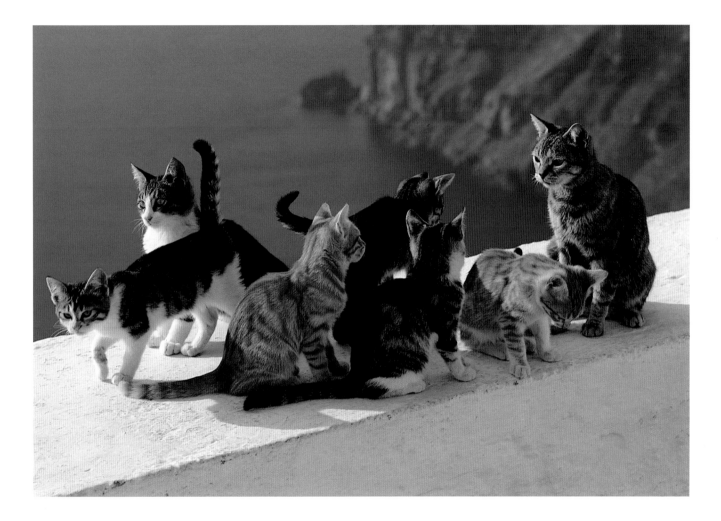

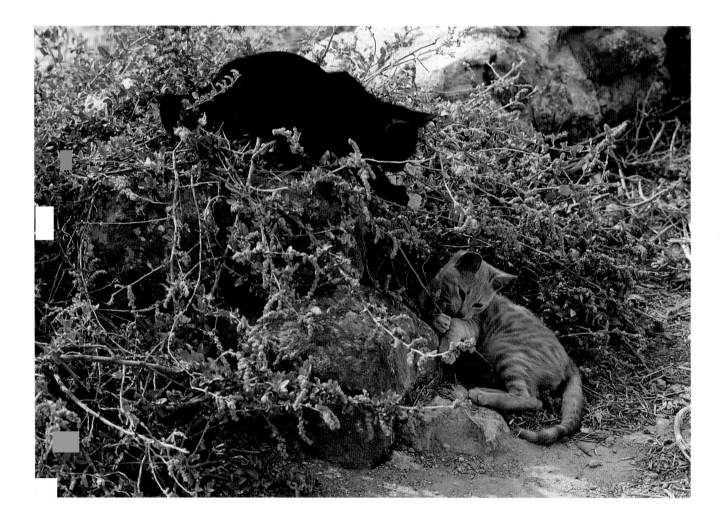

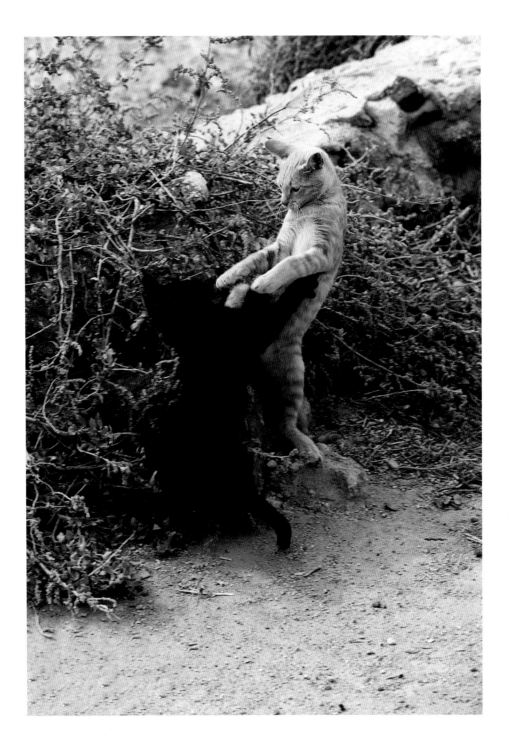

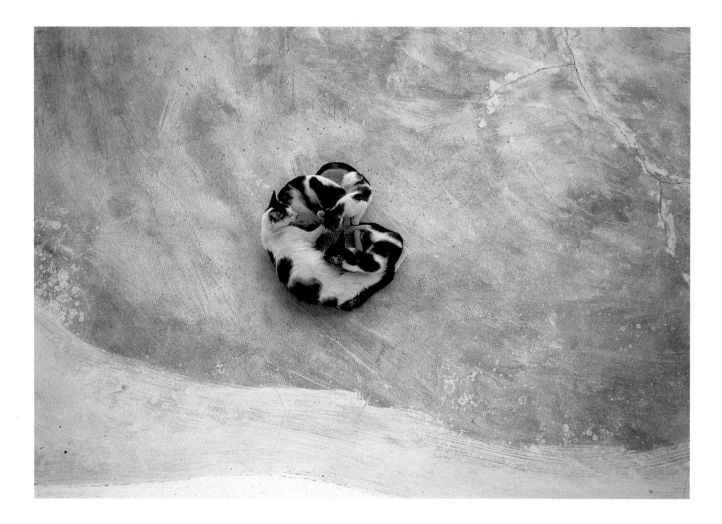

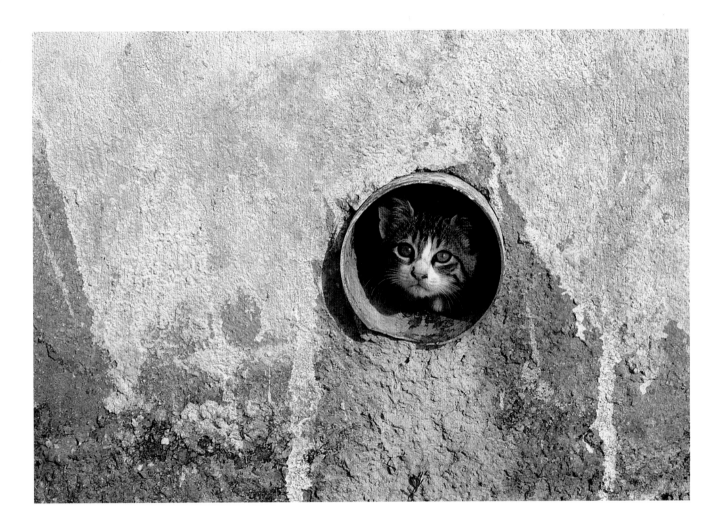

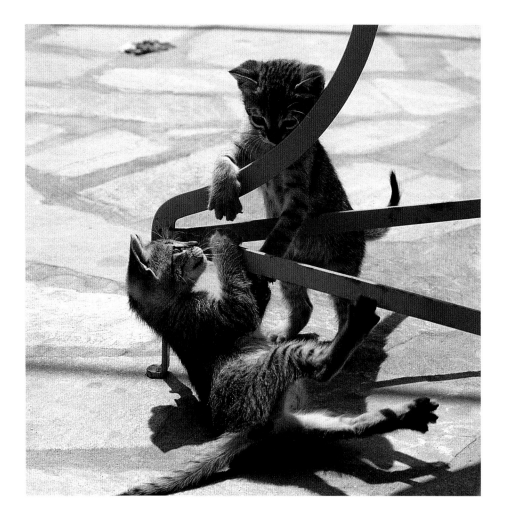

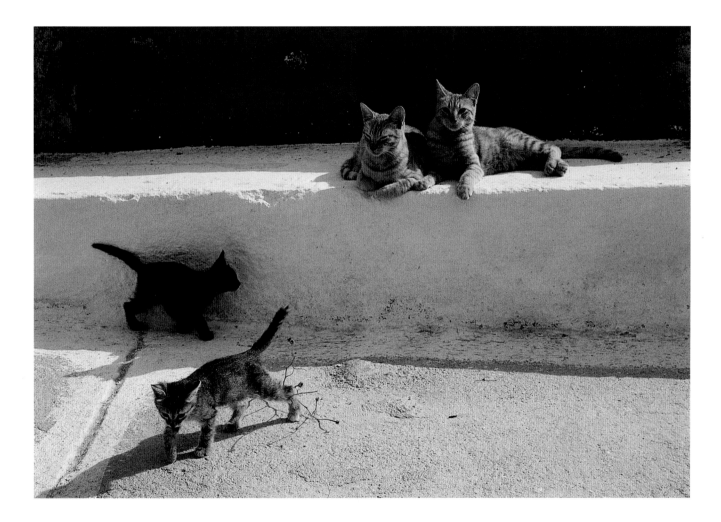

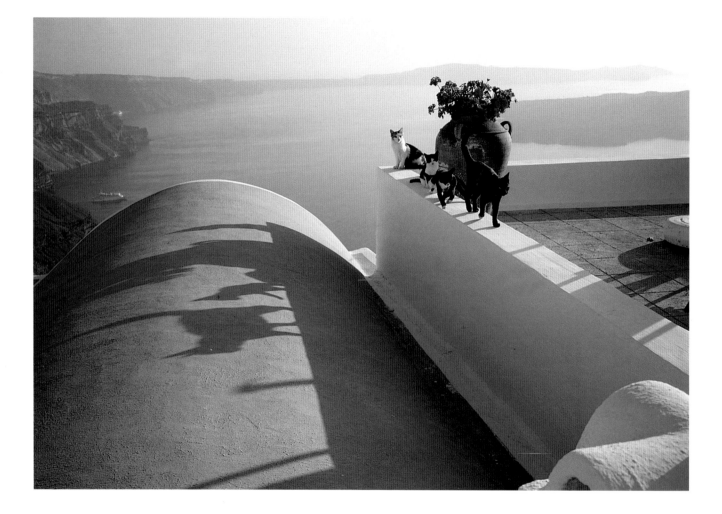

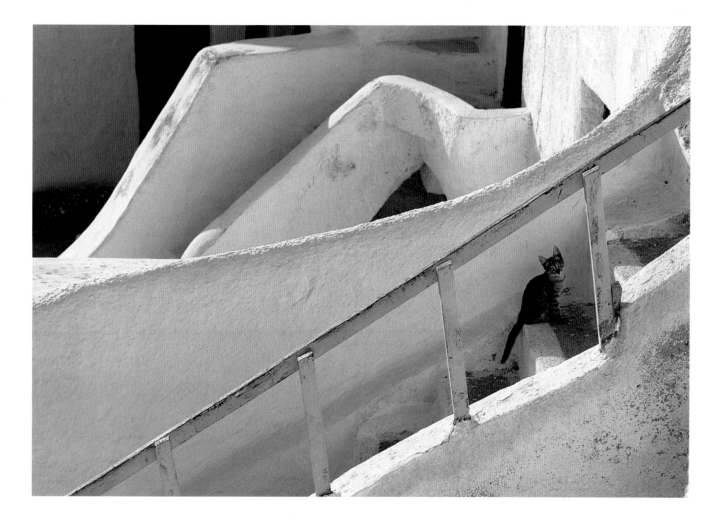

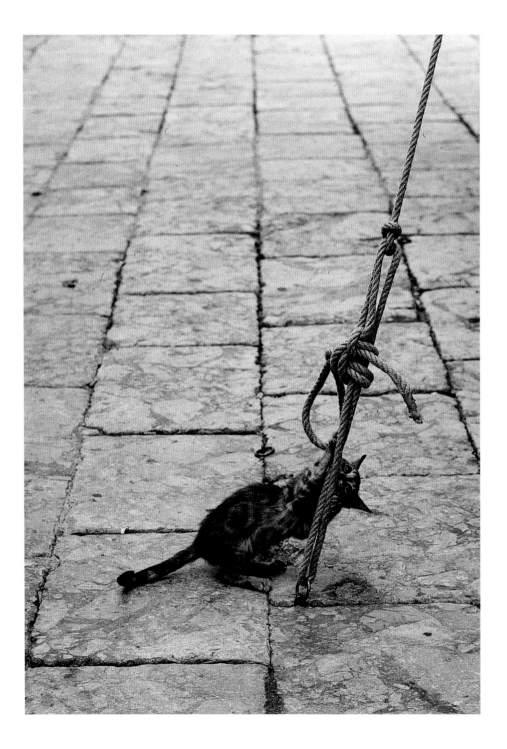

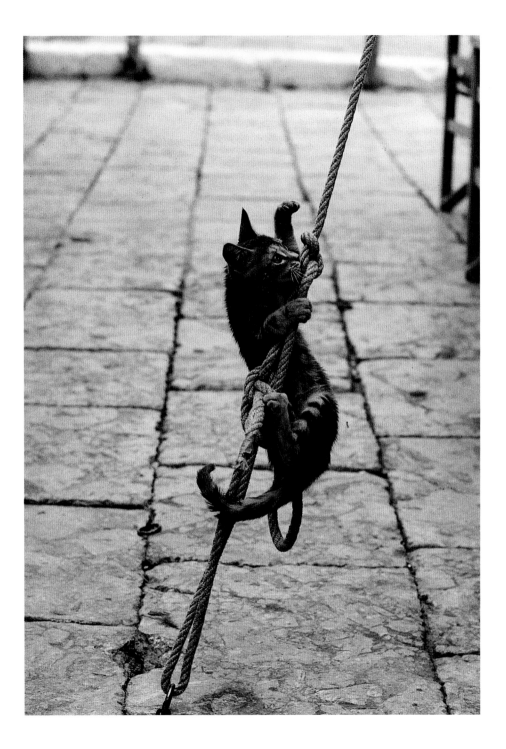

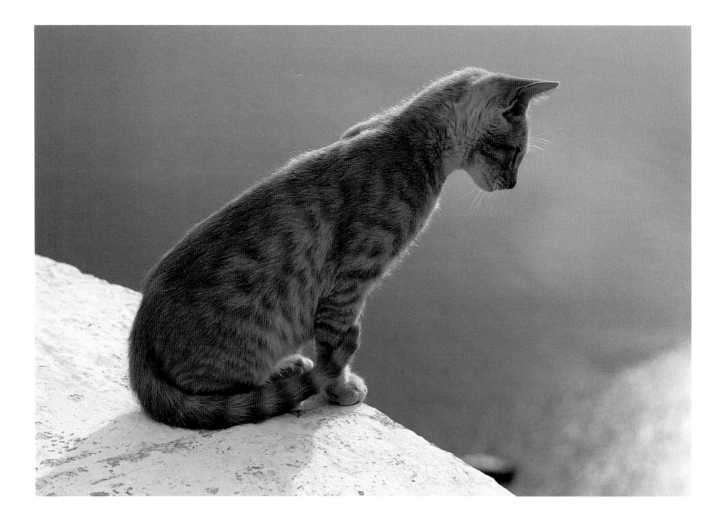

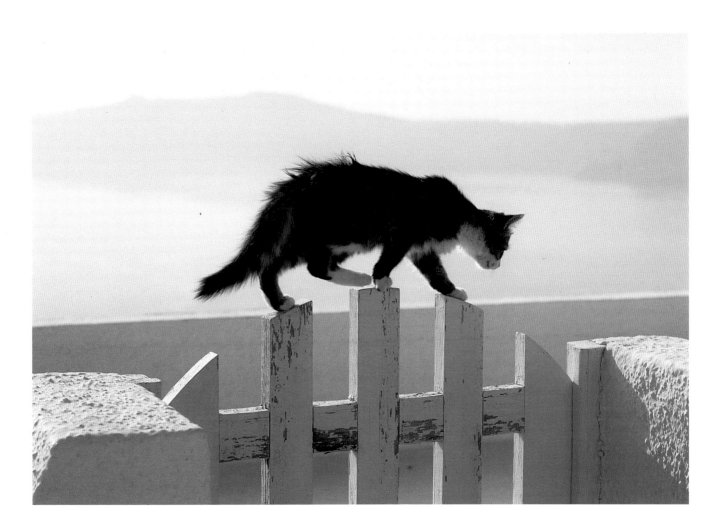

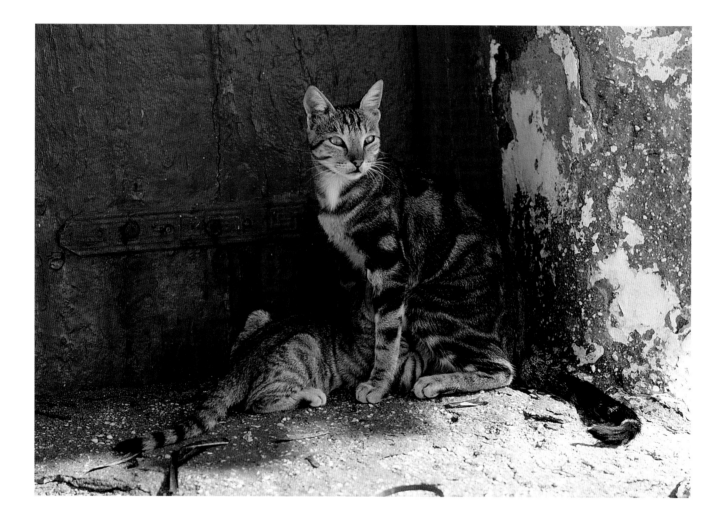

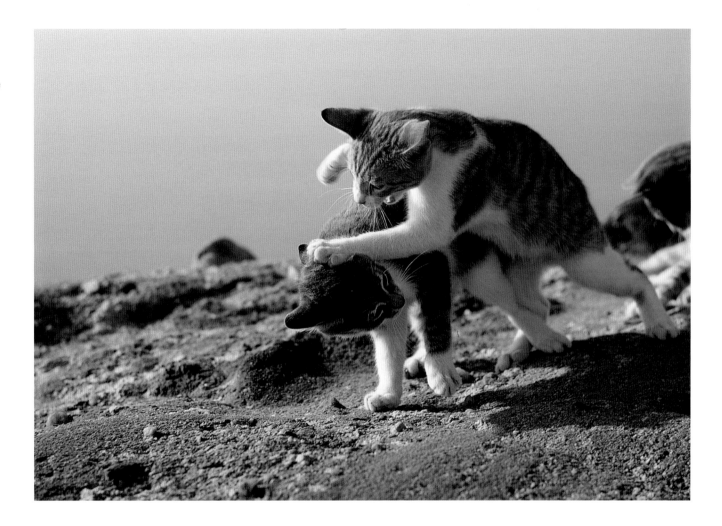

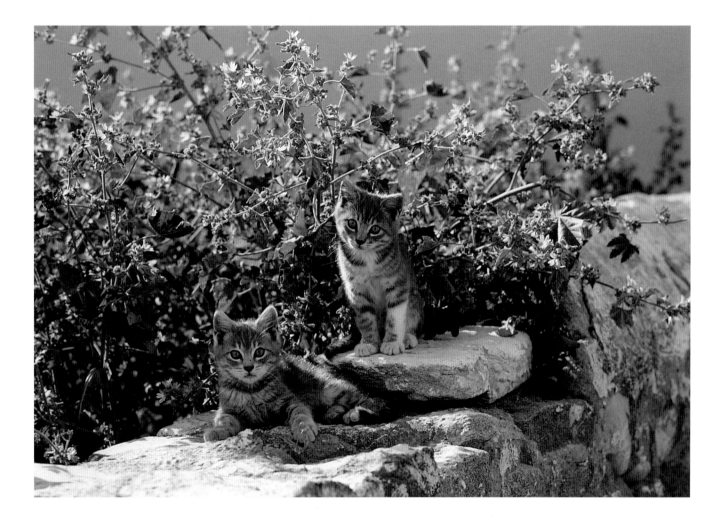

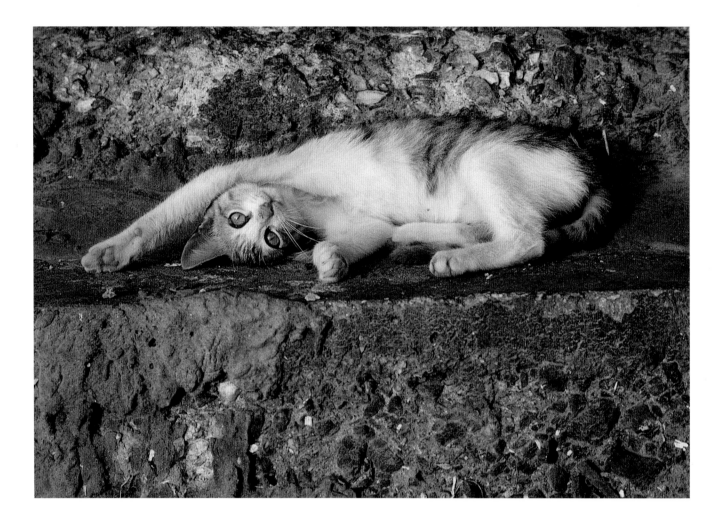

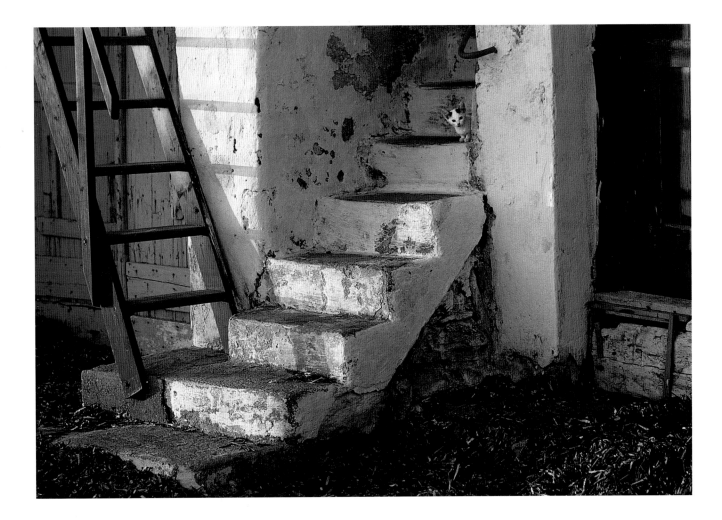

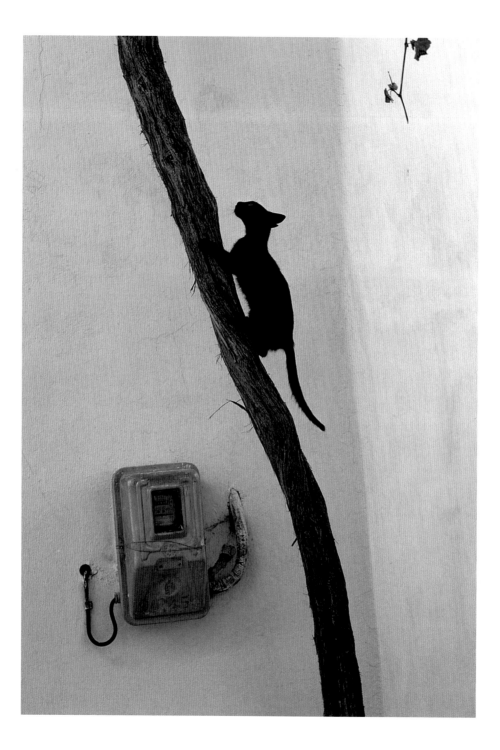

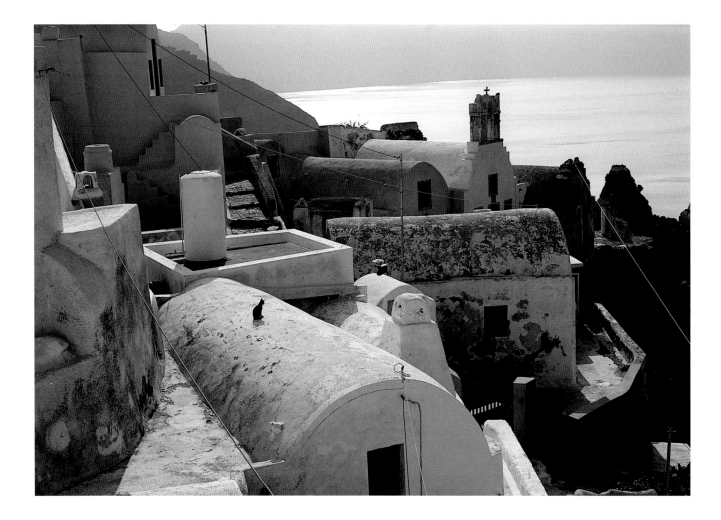

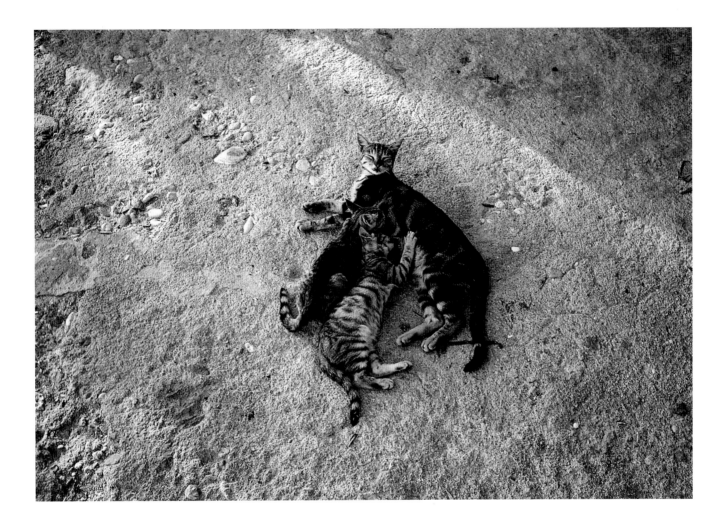

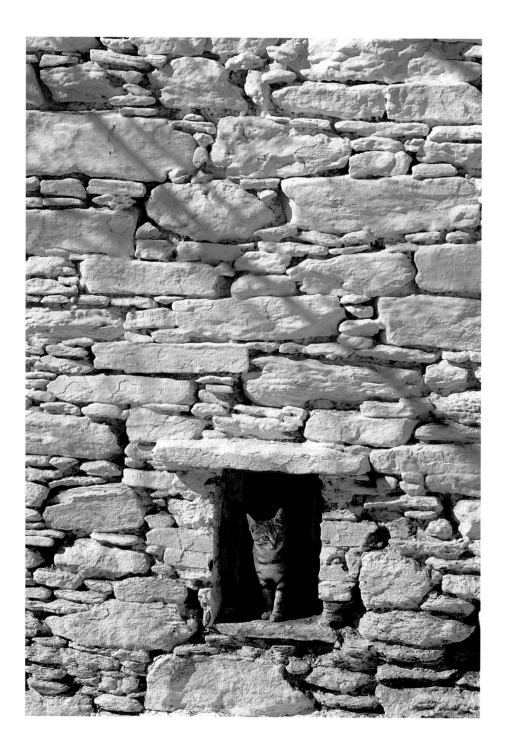

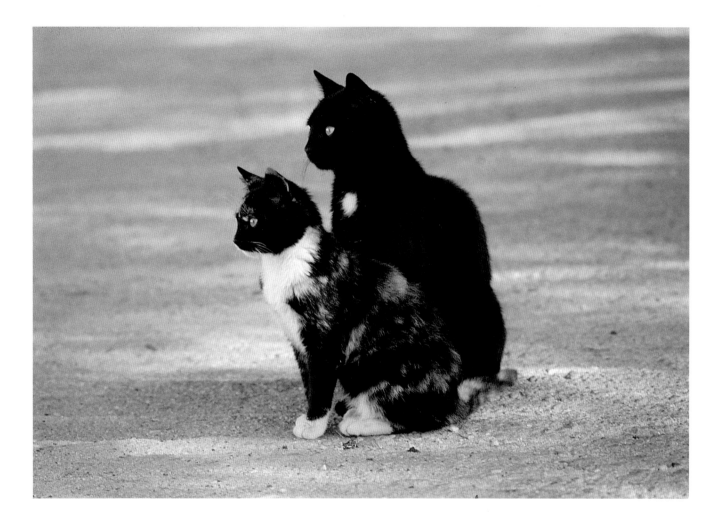

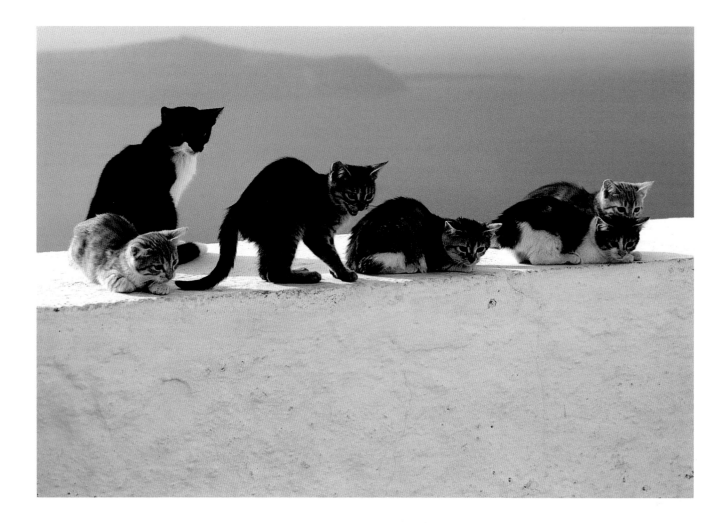

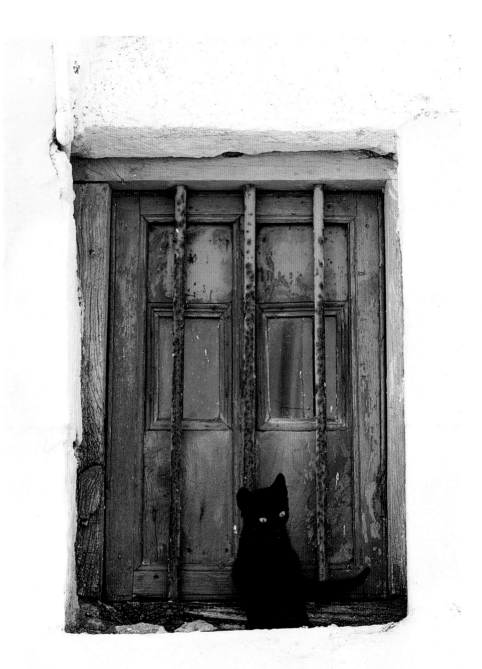

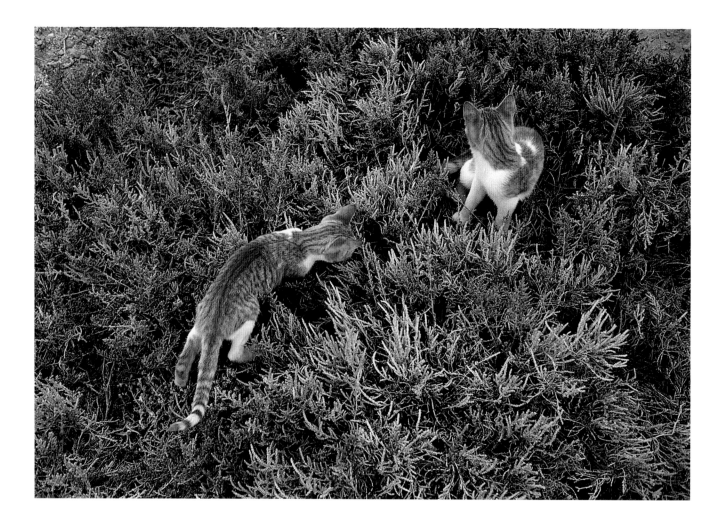

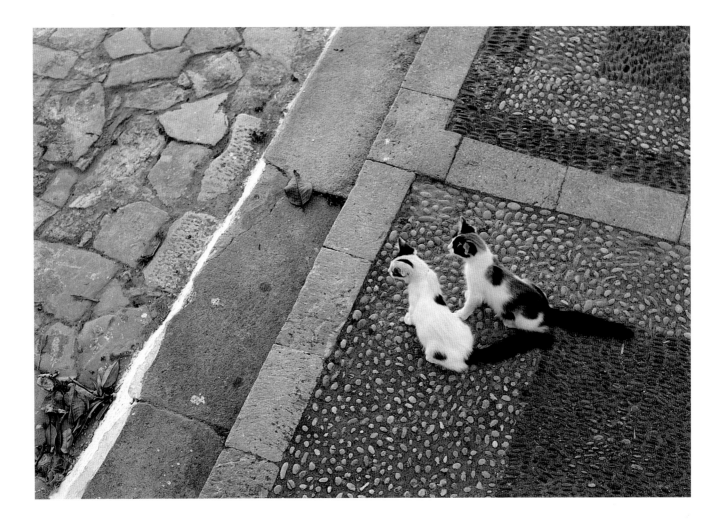

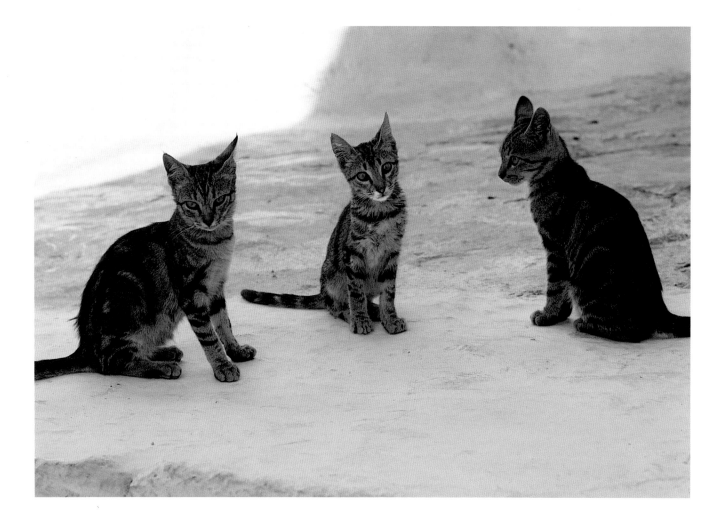

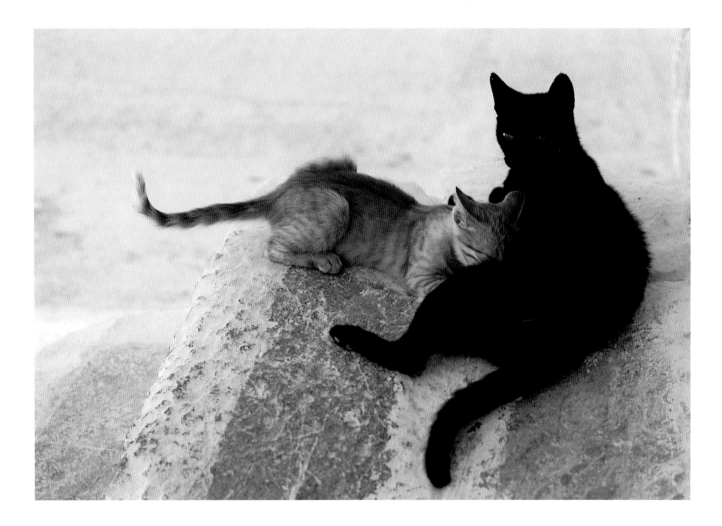

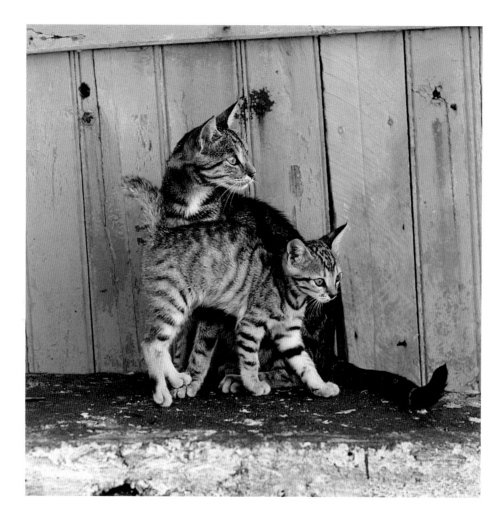

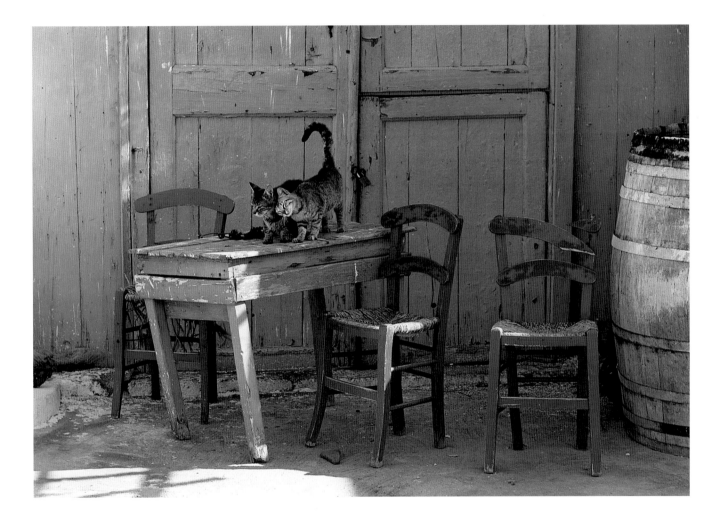

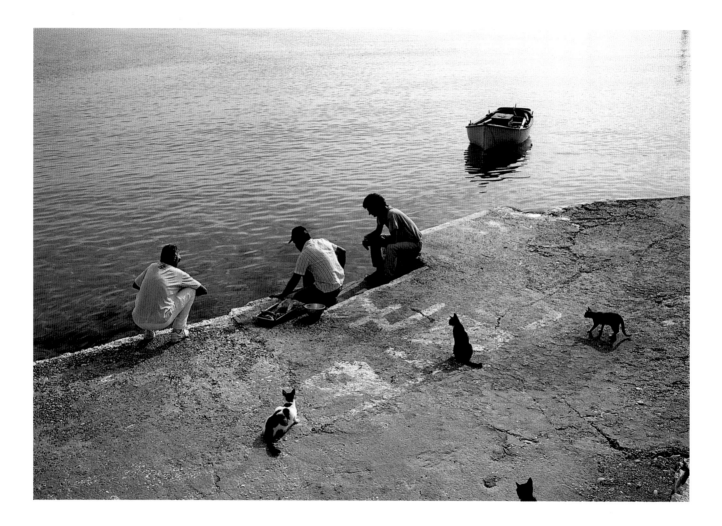

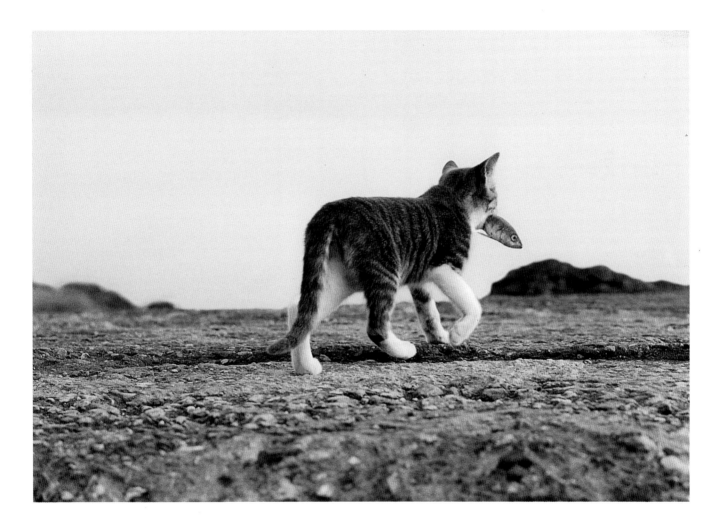

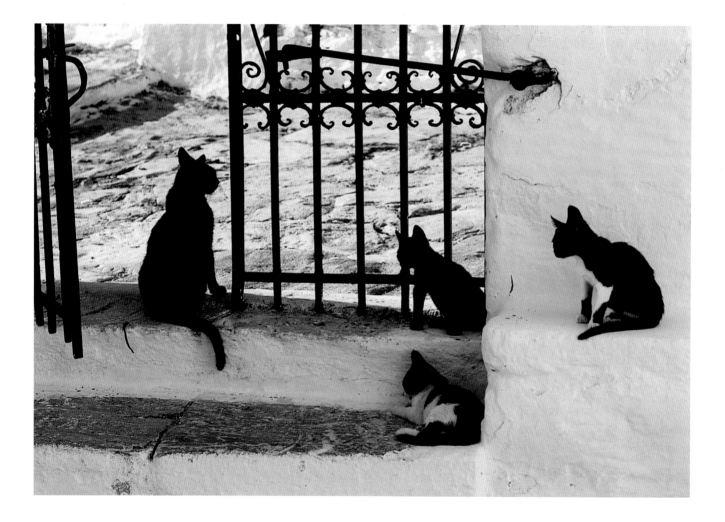

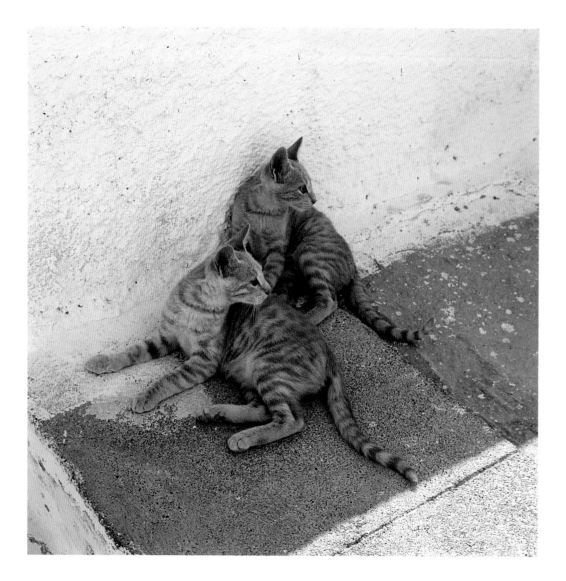

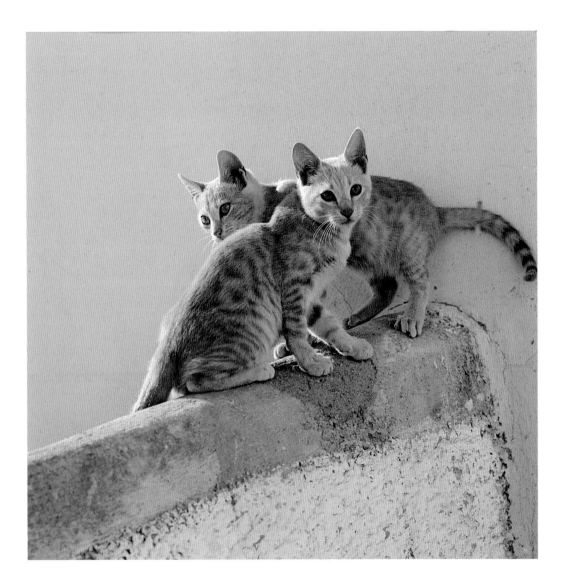

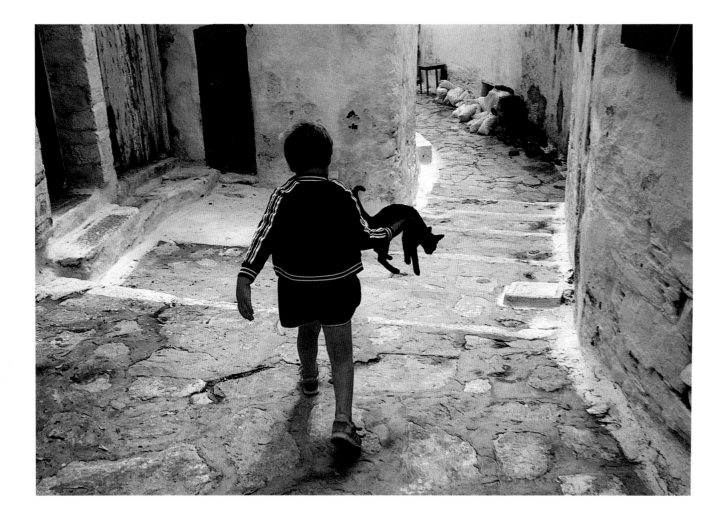

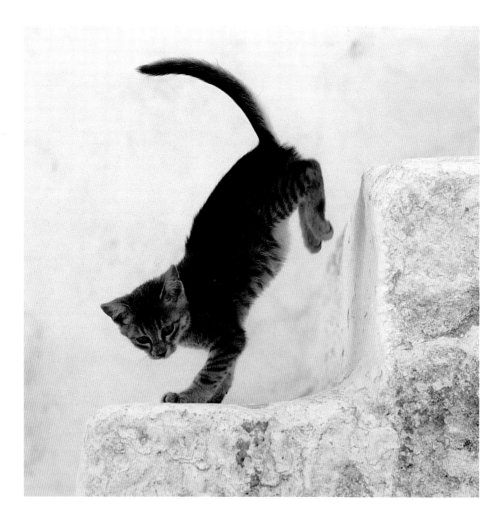

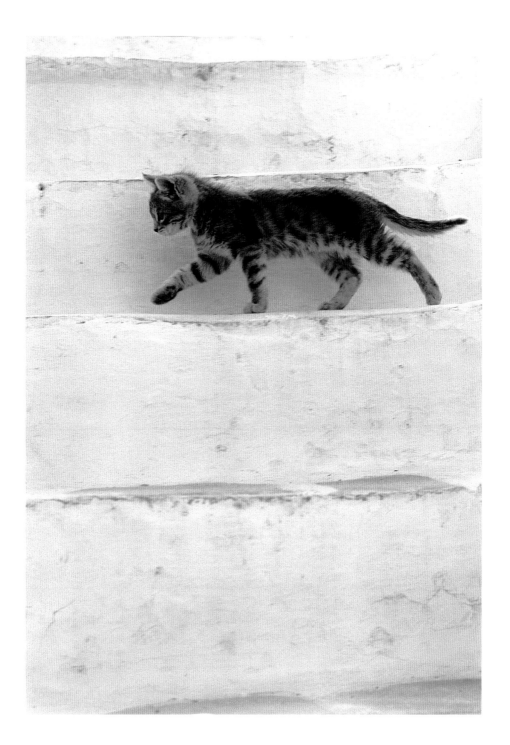

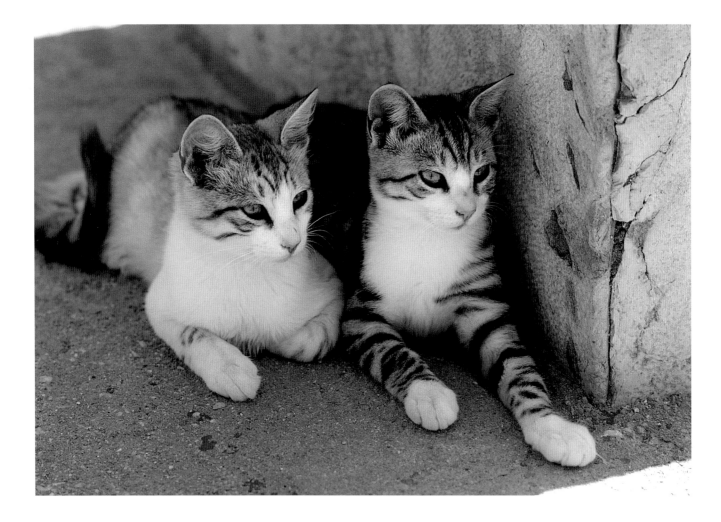

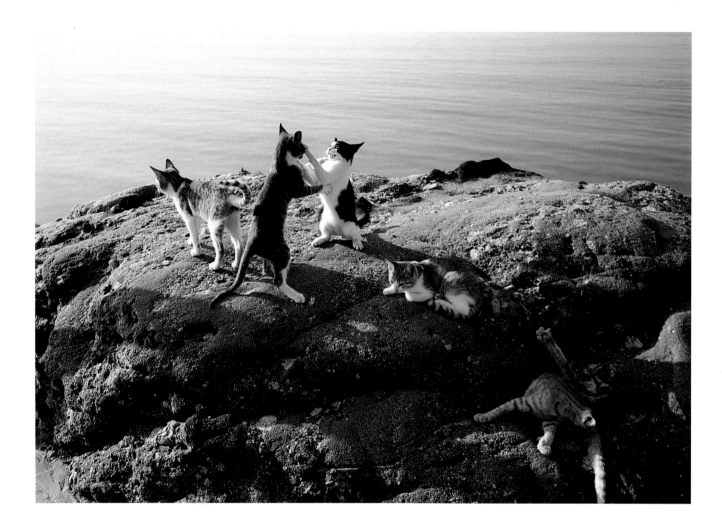

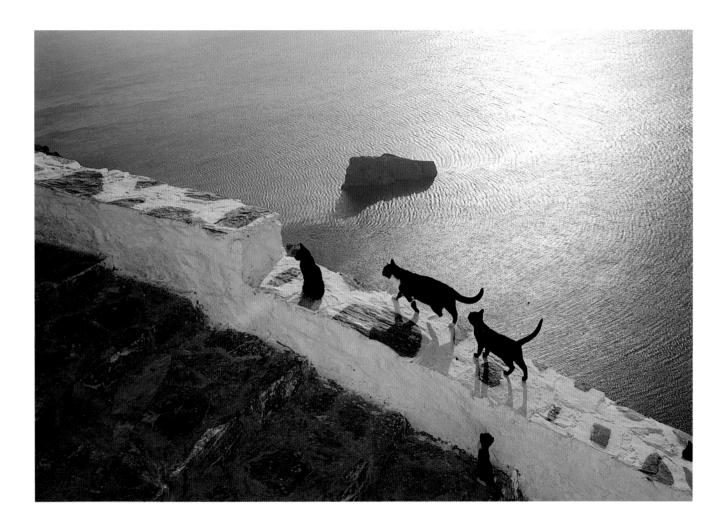

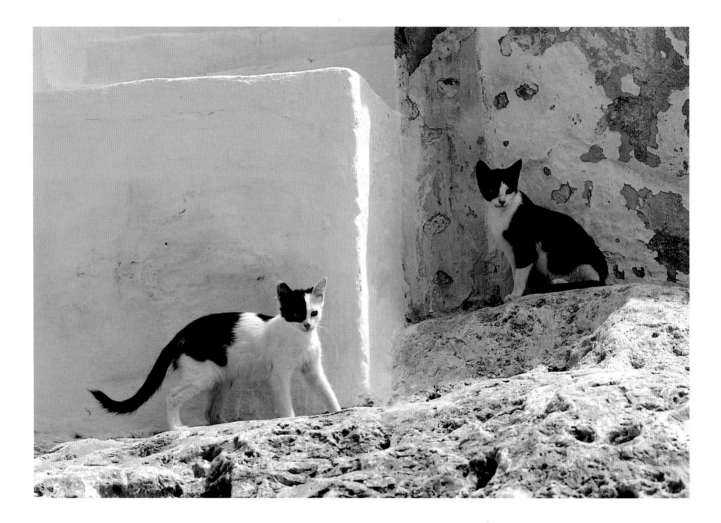

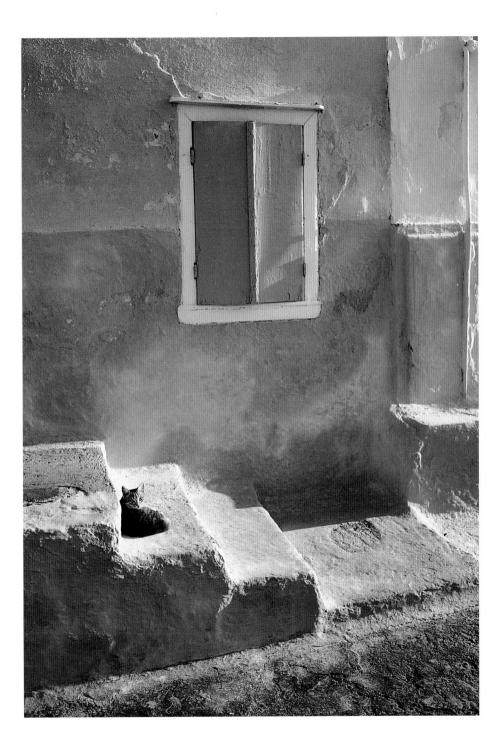

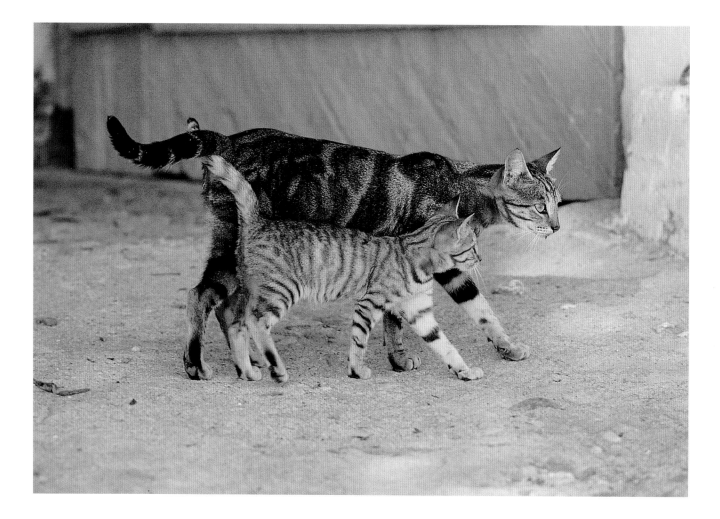

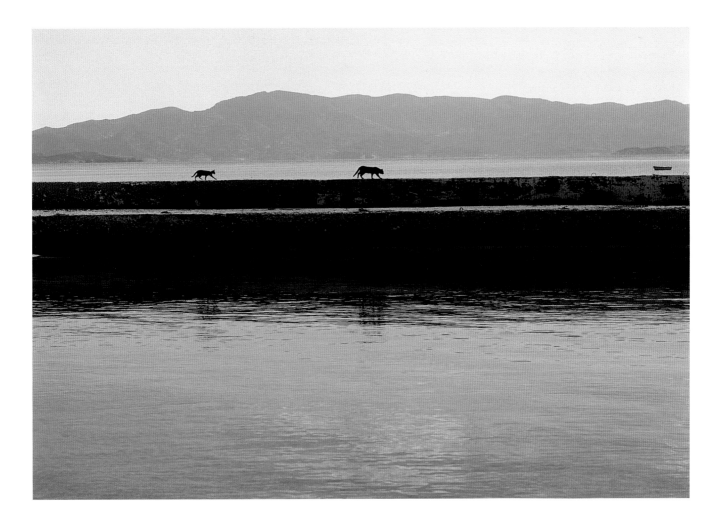

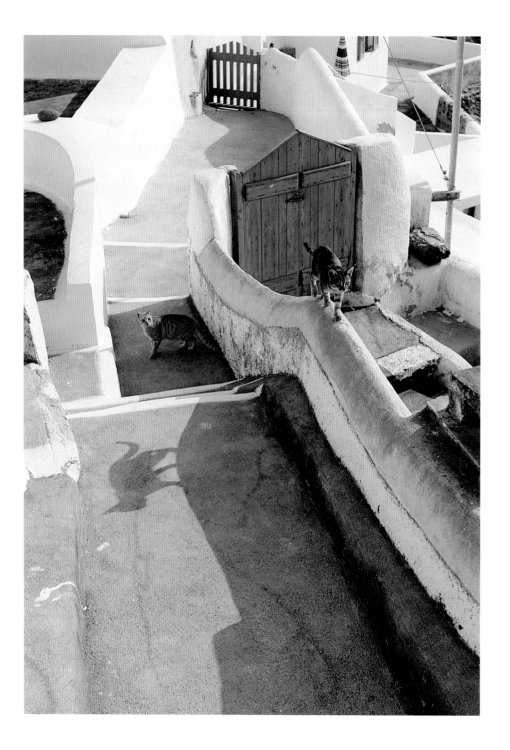

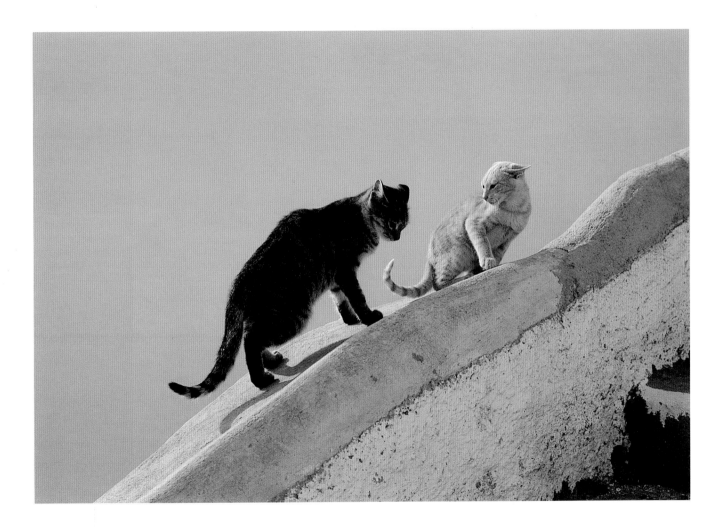

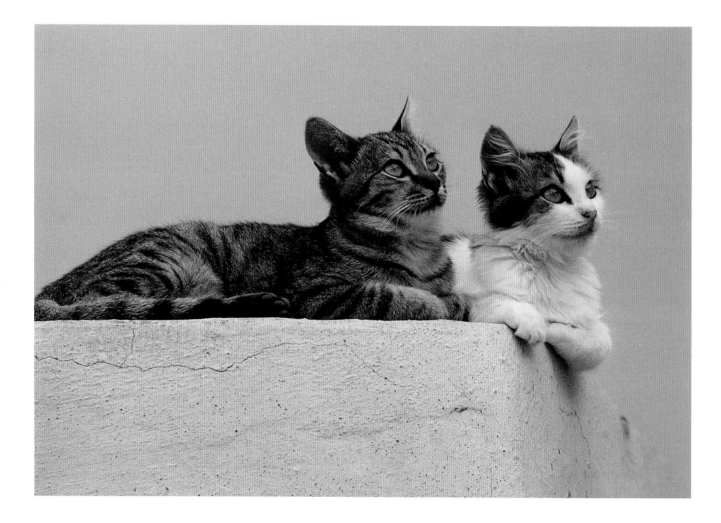

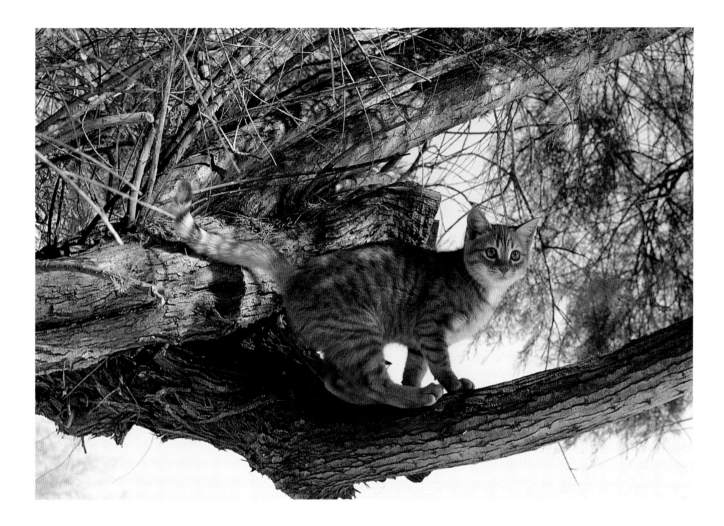

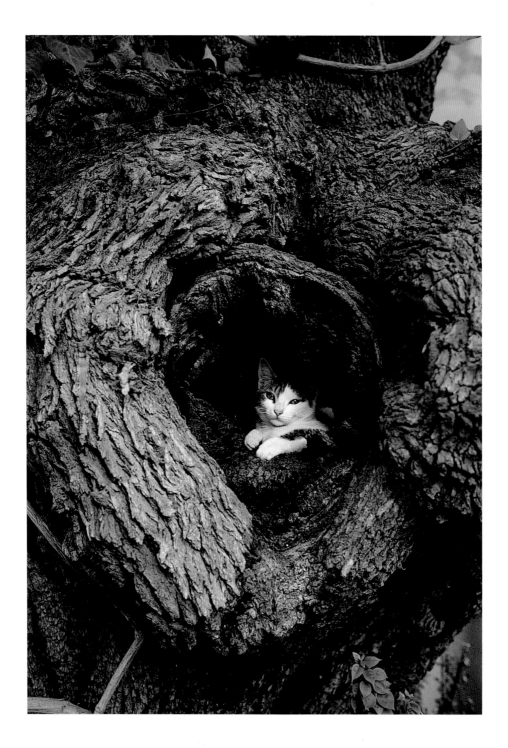

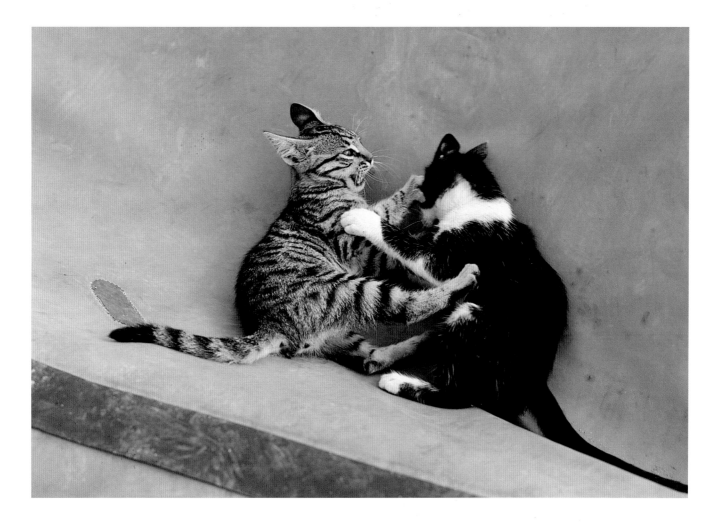

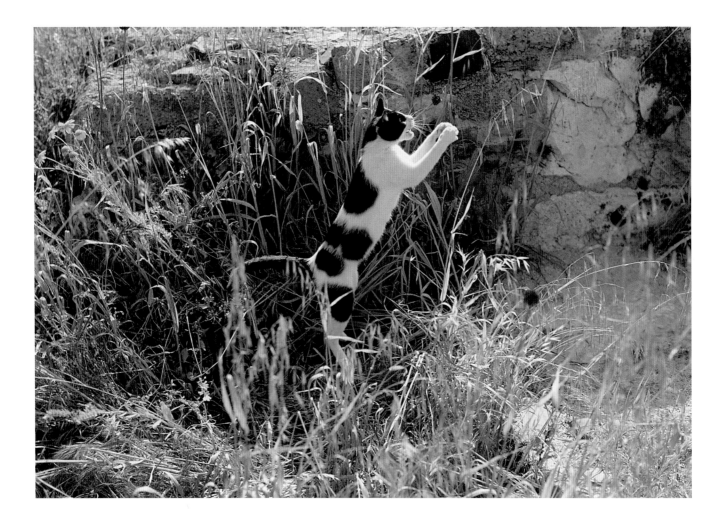

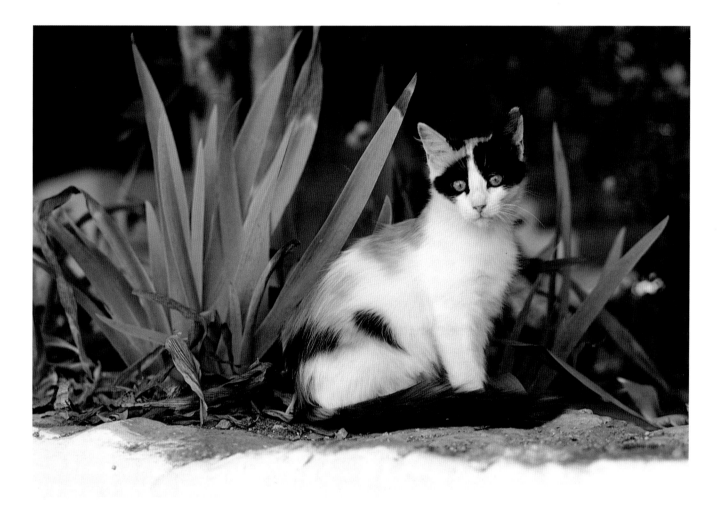

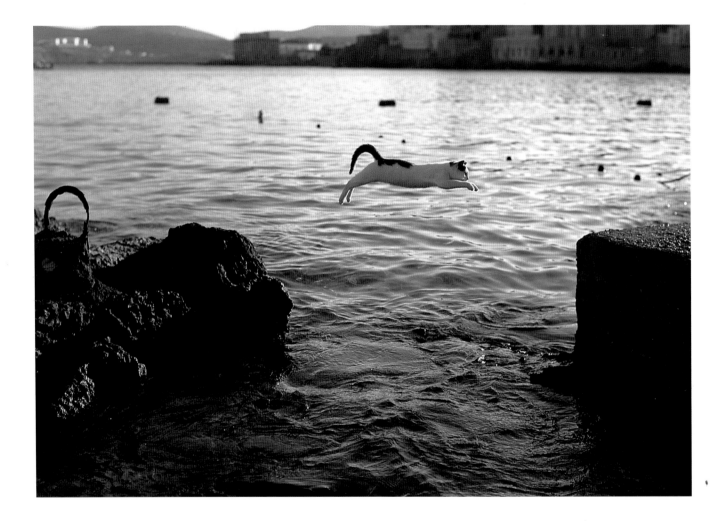

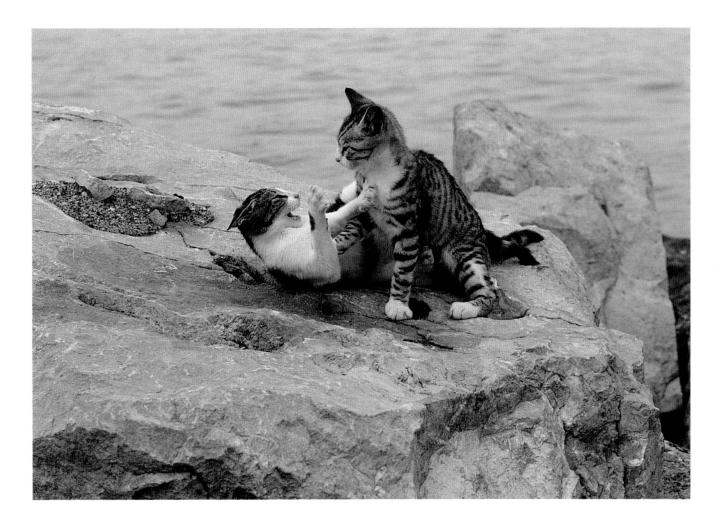

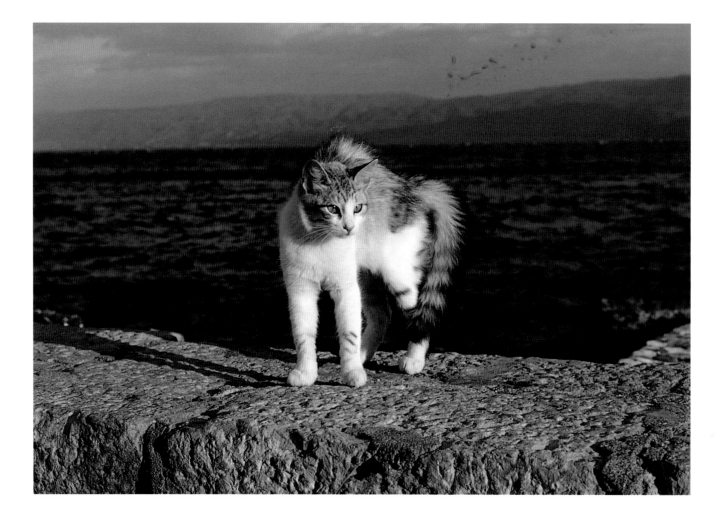

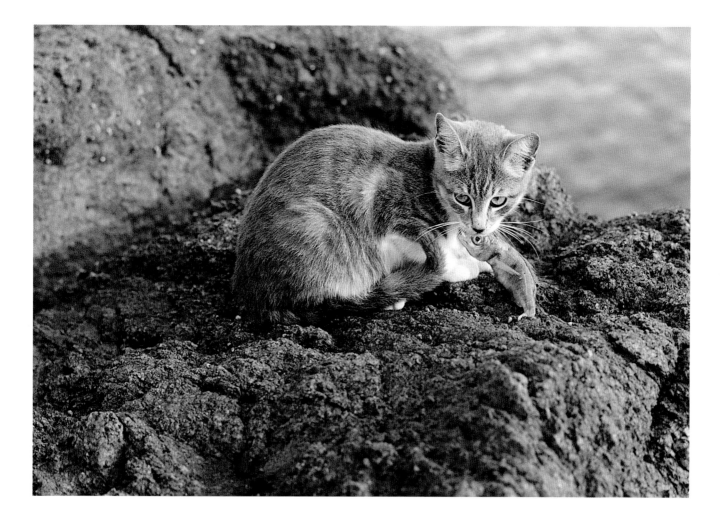

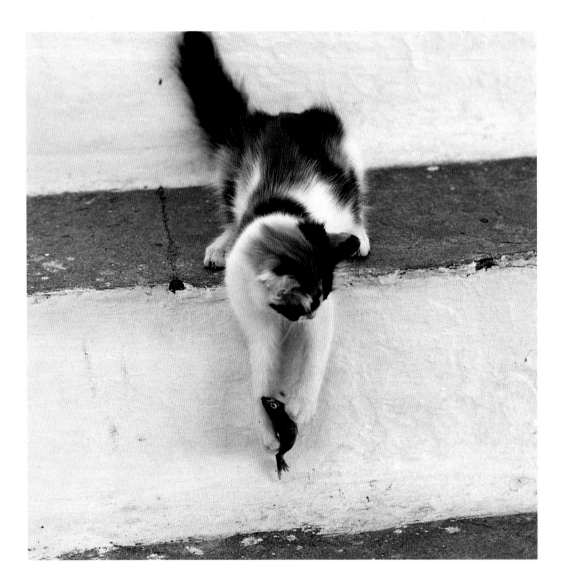

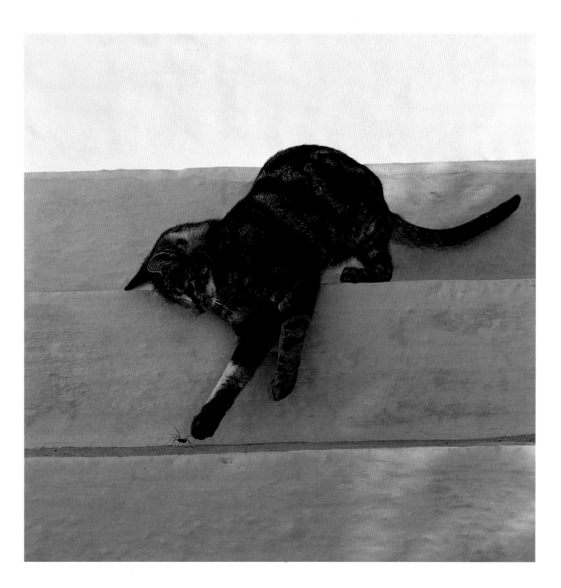

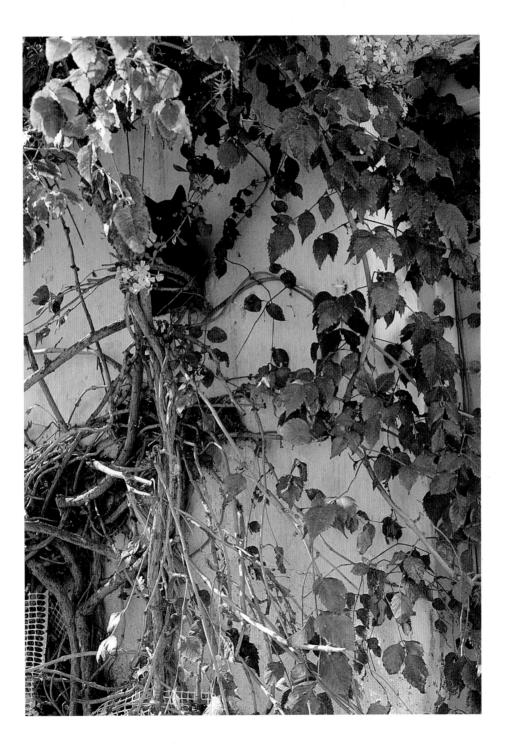

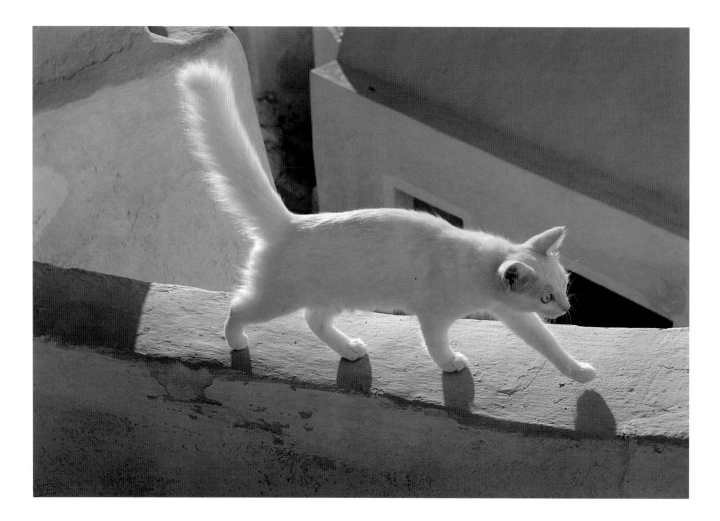

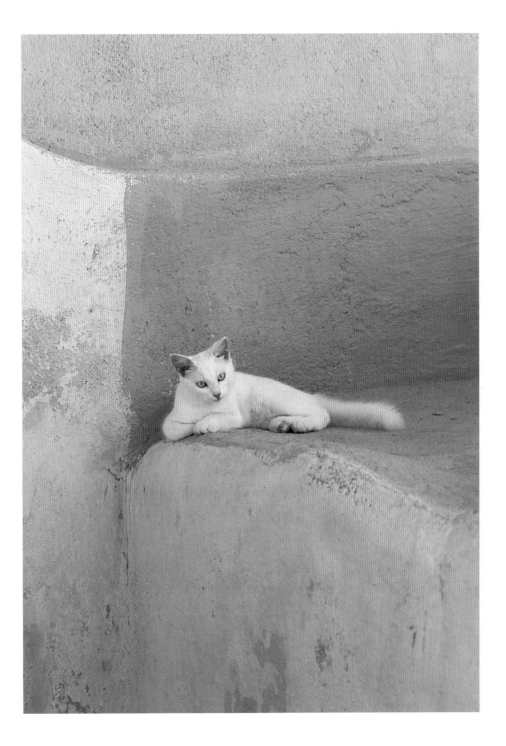

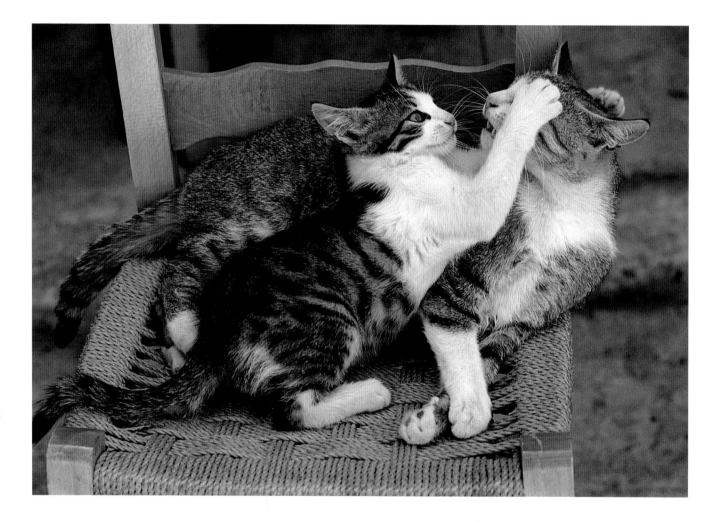

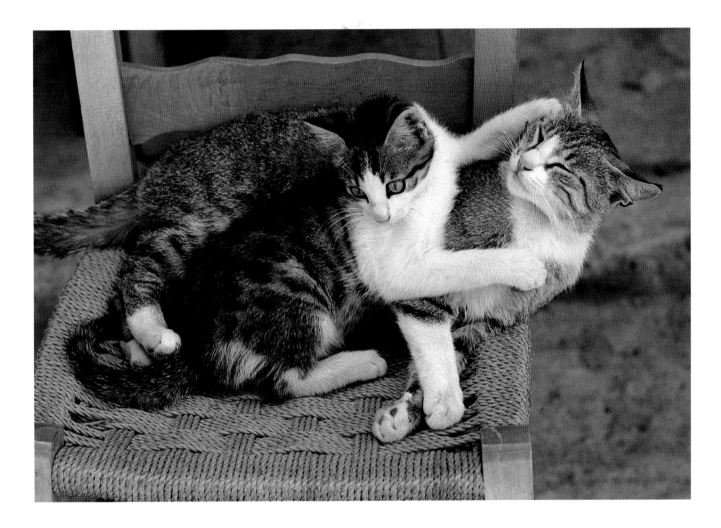

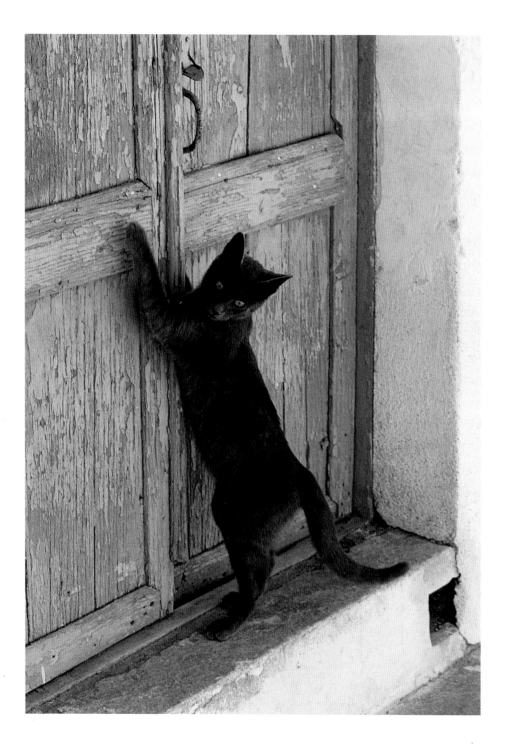

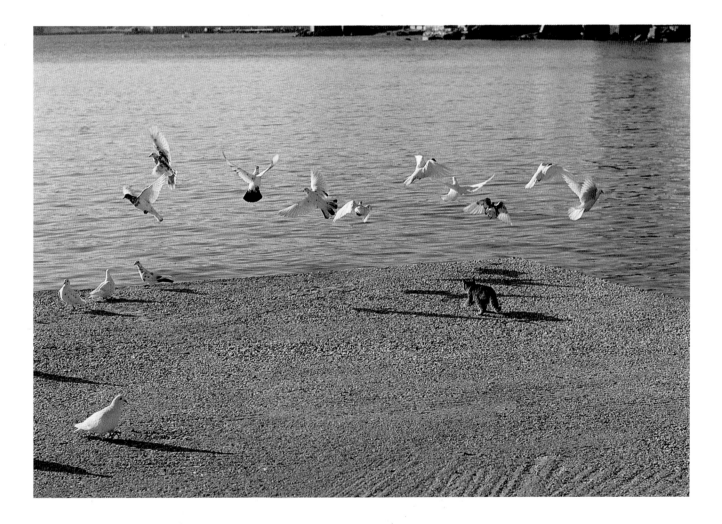

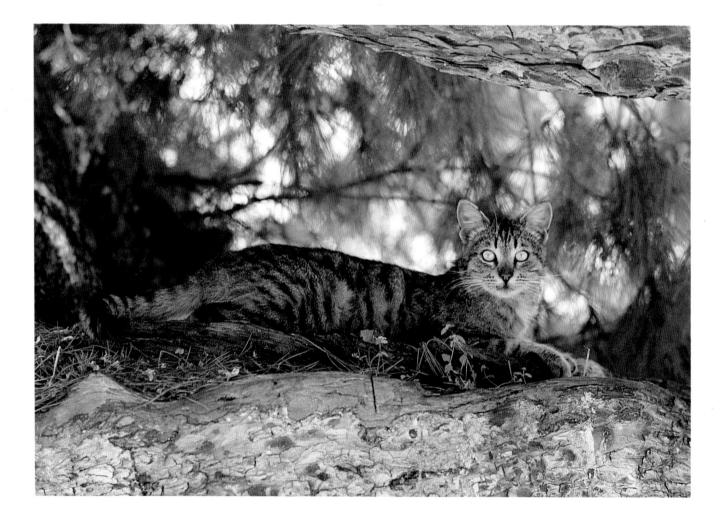